W9-BRP-528

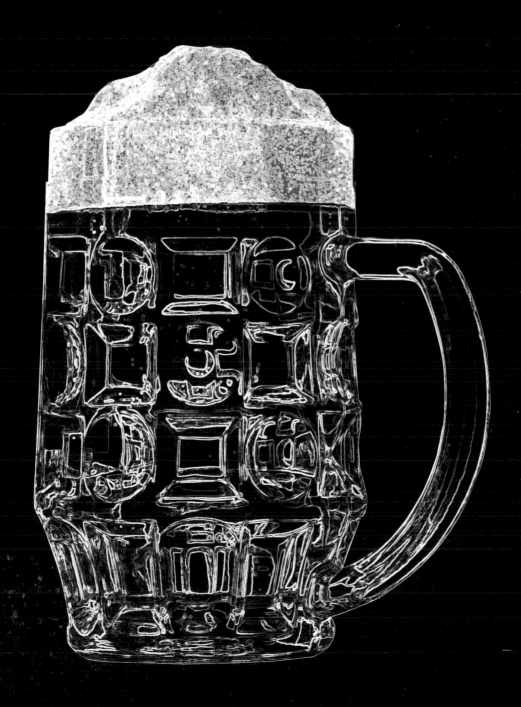

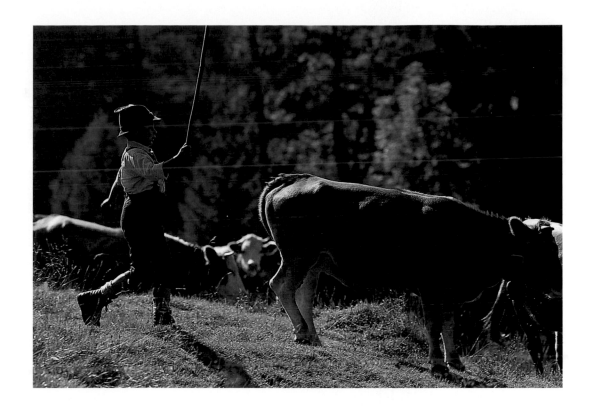

Journey through

BAVARIA

Photos by

Martin Siepmann

Text by

Ernst-Otto Luthardt

Stürtz

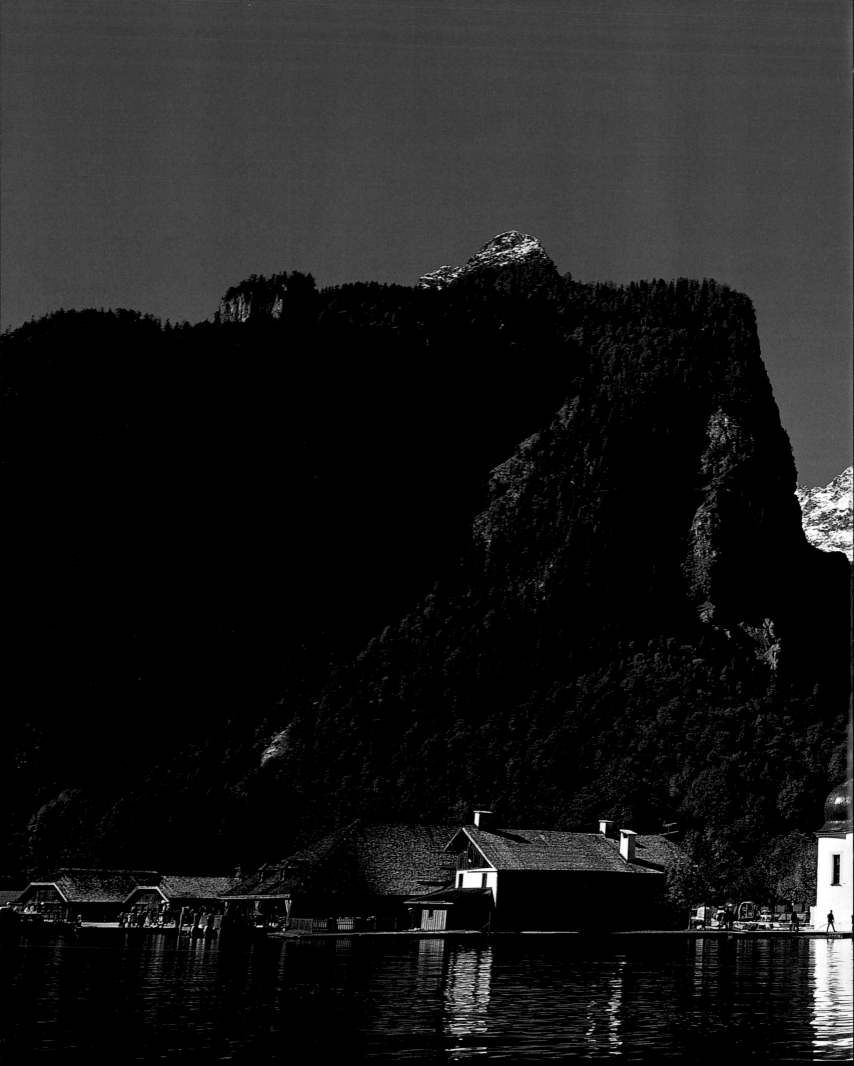

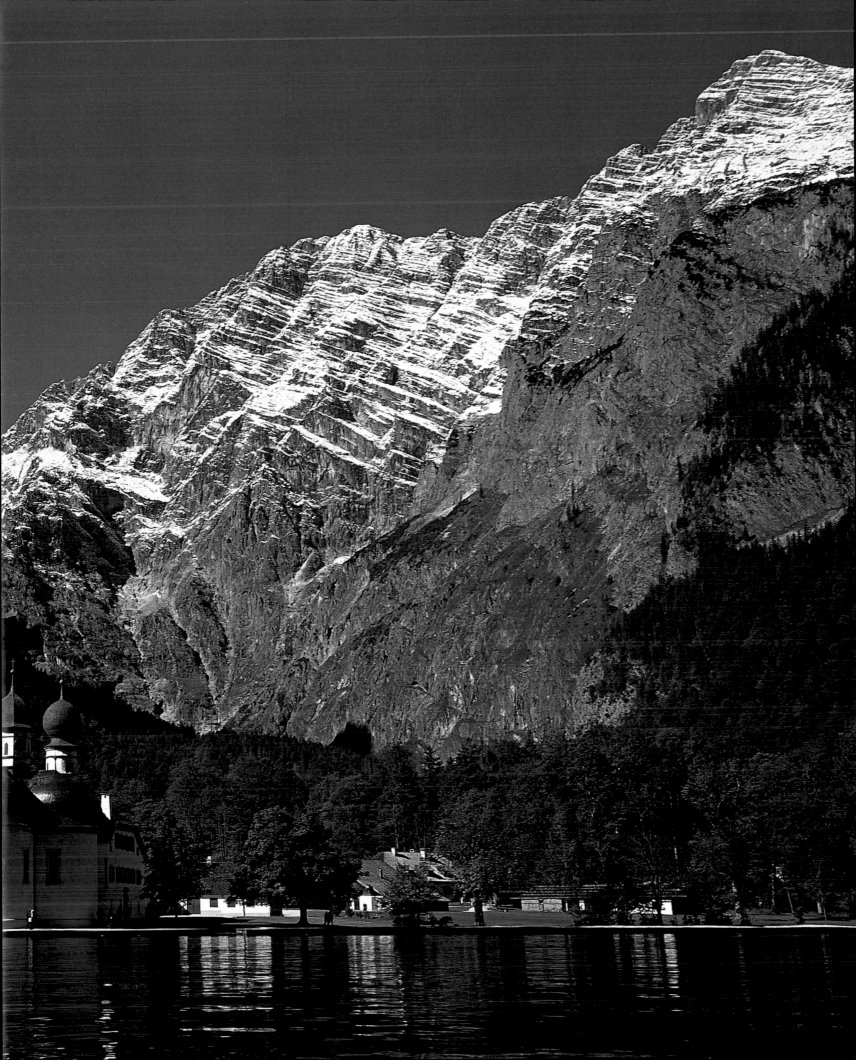

CONTENTS

First page:
*Each autumn, before the
onset of winter, the cattle
have to be driven down
from their mountain
pastures (here in Gar-
misch-Partenkirchen).*

Previous page:
*The Königssee, entirely
surrounded by moun-
tains, is one of the gems*

of Germany's Alpine lakes. The tiny peninsula of St Bartholomä lies huddled at the foot of the Kleiner Watzmann, the oldest parts of its pilgrimage chapel dating back to the 12th century.

Below:
Celebrating without music in Bavaria would be absolutely unthink-able. Here the band is playing in Rottenbuch (Pfaffenwinkel) for the Lechgau festival.

Page 10/11:
From Ussenburg there are grand views of the Tegelberg and Säuling in the Ammergebirge, with the Forggensee tucked in between them. The lake was created in 1954 when an enormous dam was erected across the River Lech.

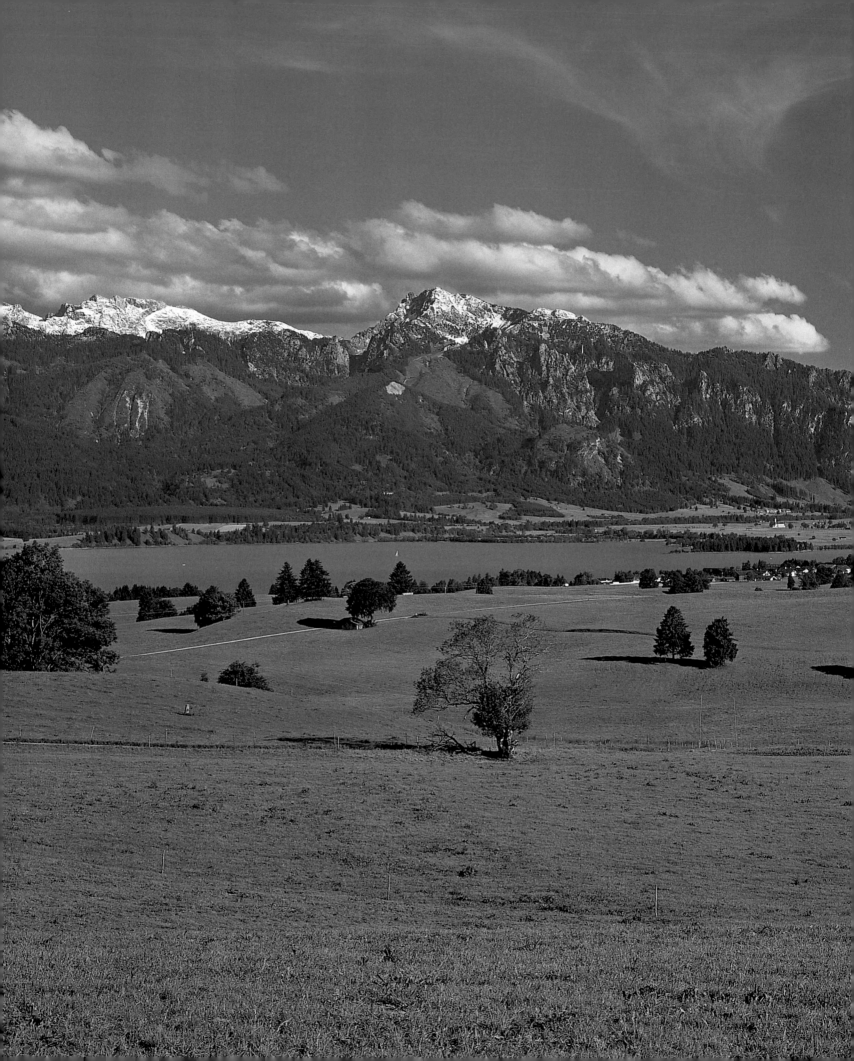

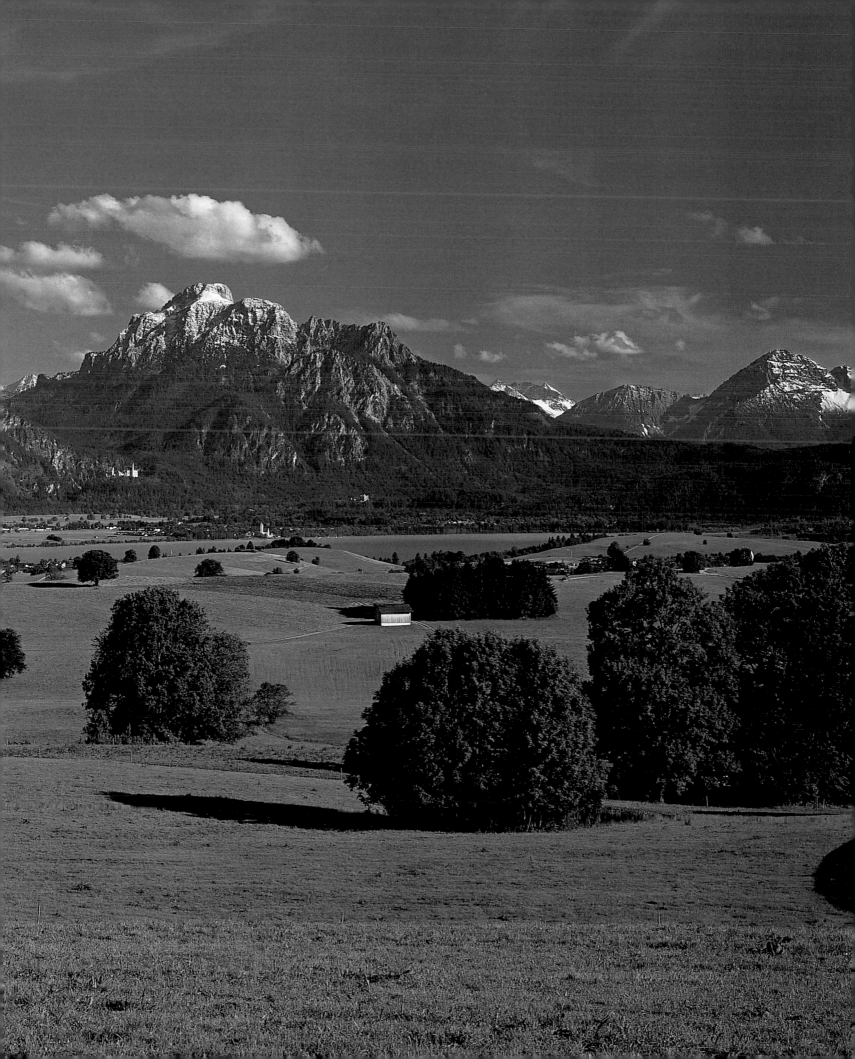

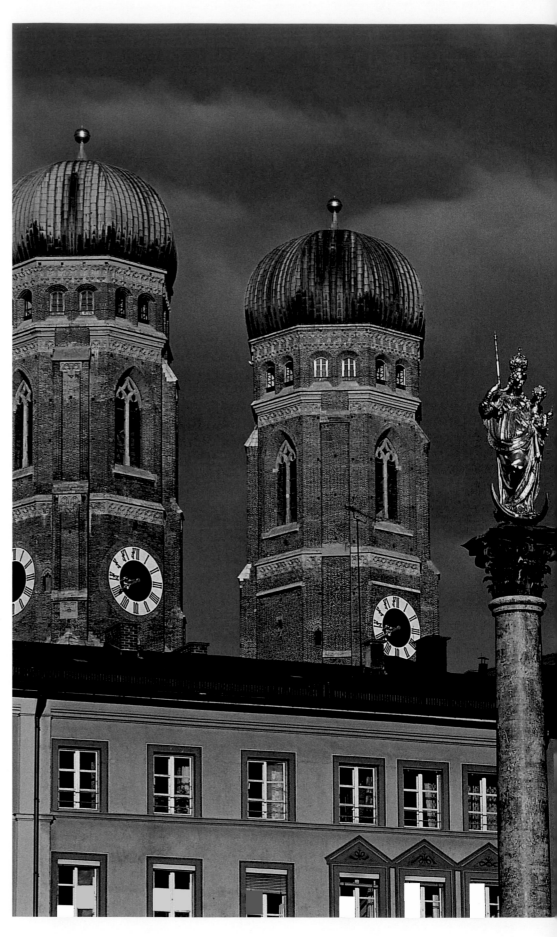

The heart of Munich beats on Marienplatz; its ornate column is the central point from which all city coordinates are measured. To the right is part of the New Town Hall with its famous glockenspiel, with the twin towers of the Frauenkirche rising up behind the houses on the left.

With a surface area of a good 70,000 square kilometres (27,000 square miles) Bavaria is the largest federal state in Germany. It has around 12 million inhabitants spread out across »old Bavaria« (Upper and Lower Bavaria and the Upper Palatinate), Swabia and Franconia. The latter two territories were annexed during the Napoleonic era following several spectacular exchanges of land, the first under the auspices of The Little Corporal and the last – after the Bavarians had swopped sides during the Wars of Liberation – without any intervention on his part. Bonaparte was also the man who graciously allowed his newly-acquired allies the luxury of a sovereign ruler. From 1 January 1807 onwards the elector was permitted to call himself King Maximilian Joseph I. Ludwig I, his son and successor (1825–1848), even went as far as to plead the case for the monarchy in an extremely shaky rhyme:

Honest folk of traditions true
Stand by your ancient royal house.
Be not swayed by the false and the new
Let the flame of love be not doused.

Funnily enough, it wasn't Ludwig's royal subjects who went off in search of »the false and the new« but the king himself. He fell for a certain Lola Montez, a 'lady' of dubious

pedigree who didn't exactly meet the requirements of royal protocol. Travelling the country as a 'dancer', she proved tantalisingly irresistible to her many admirers both on stage and in the flesh. King Ludwig fared no better than the love-struck individuals who had gone before him – and who were to succeed him – falling prey to Lola's wily charms. His underlings exercised patience for a while but not indefinitely. Ludwig eventually lost both his crown and his mistress. In the same year, 1848, which saw the event of Germany's revolution, the tempers of the good burghers of Munich were again sorely tried, not because they had been denied their civil rights but because – far more importantly – the price of beer was raised. Three quarters of a century later the news was thus all the more astonishing that the Bavarians of all people had deposed their king and been taken over by a soviet government. Although the regime only lasted for a brief spell, the new situation in Germany resulted in the procurement of a new – and totally unexpected – stretch of land for Bavaria. With no kings left to exercise their monopolies, in a plebiscite in 1920 the inhabitants of Coburg, then part of Saxon Thuringia, voted to become Bavarian. They may have been welcomed with open arms but their culinary contribution to the merger, the large, pork Bratwurst, was not – especially in Nuremberg with its previously unchallenged spicy chipolatas ...

THE BAIUVARII

2,000 years ago, the then Celtic settlers of Bavaria, ensconced in their hill forts and oppida for a good few centuries, had far more important things on their mind than squabbles over sausages. Their war was with the Romans, who came and conquered in the knowledge that they belonged to a more modern and superior race. 15 BC signalled victory for the Romans – and defeat for the Celts. The new provinces were named Rhaetia and Noricum; military camps swelled into towns called Parthanum (Partenkirchen), Radaspona (Regensburg) and Batavis (Passau). The famous historian Tacitus went into raptures about Augusta Videlicum (Augsburg), »the most delightful settlement in the whole of Rhaetia«. Numerous excavations have unearthed hundreds of relics from this period, the last spectacular find being in 1979 when archaeologists discovered valuable Roman treasure buried in Weißenburg in the heart of Franconia.

The new kings of the castle(s) staked out the northern boundary of their empire with the Limes. The Celts – at least those who didn't put up too much resistance – were assimilated. During the migration of the peoples Germanic tribes mingled with the existing Celto-Roman population. Contrary to popular belief, the Baiuvarii were thus not immigrants but the product of a gradual ethnogenic process.

FROM THE DUKES OF AGILOLFING TO THE HOUSE OF WITTELSBACH

The earliest Bavarian duke on record is Garibald (c. 550–590) and the first seat of government Regensburg, from whence Bavaria was ruled for over half a millennium. The Agilolfing dynasty reigned until 788 when Charlemagne deposed Tassilo III and added the Bavarian stem or tribal duchy to the Frankish Empire. Tassilo was ordered to spend the rest of his days in monastic confinement – ironically so, as the Agilolfing dukes were the first to introduce Christianity to their domain.

The new ecclesiastical structure of Bavaria encompassed various bishoprics and a network of around 50 monasteries – the founding of which was in many cases largely down to the aforementioned Tassilo. Some of the famous monastic strongholds which have survived from this period are Thierhaupten, Frauenwörth, Weltenburg and Benediktbeuern. The first German alliterative poem, the 9th-century Wessobrunn Prayer, was allegedly composed at Wessobrunn Monastery and the prototype German courtly romance, the Ruodlieb from the last third of the 11th century, is also attributed to a friar from the Tegernsee.

Bavaria's age as a territorial duchy began with the Luitpoldingers and was continued through the Bavarian line of the royal house of Saxony. The last male heir, Duke Henry IV, was crowned Henry II, emperor of Germany, in 1014. Following a brief interlude under Salian rule without an appointed duke, in 1070 the Welfen took control of Bavaria, with Henry the Lion establishing the city of Munich in 1158.

Two decades later saw the rise to power of Otto I and the commencement of over 700

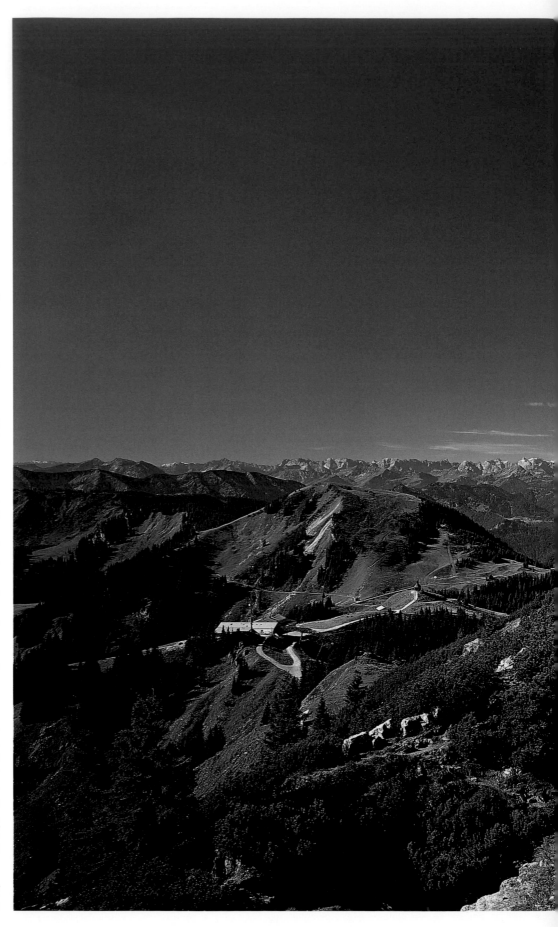

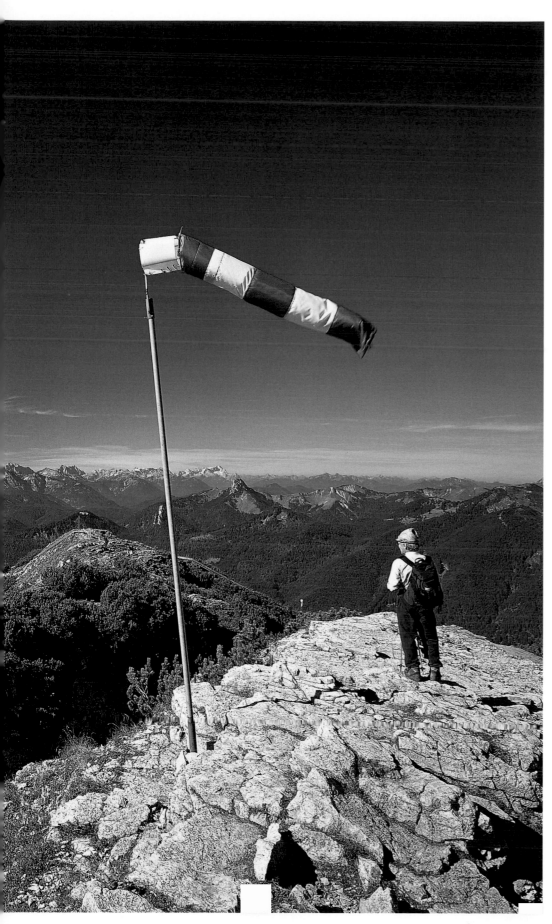

The Wallberg in the Mangfall Mountains, 1,722 metres (5,650 feet) in height, is the Alpine landmark of the Tegernseer Land and accessible by road and cable car.

The trip is well worth it for the fantastic panorama of the Setzberg, Karwendel and Wetterstein which awaits you at the summit.

years of Wittelsbach rule. The name Wittelsbach is not only inextricably linked to the obligatory military and political wranglings common to any influential dynasty but also to rather more peaceful campaigns from which artists in particular greatly profited – in the Renaissance under dukes Albrecht V and William V and in the baroque under the »Blue Elector« Max II Emanuel. Of the Wittelsbach kings Ludwig I may have become a laughing stock with his Lola Montez but he also did much to promote neoclassical art and architecture. His son and successor, Maximilian II, however, proved even more of an architect than his father, his name now used to describe a particular style of building. Yet the most famous Bavarian monarch of them all was Ludwig II, locked away in a fairytale dreamland which created the well-known chocolate-box castles of Neuschwanstein, Linderhof and Herrenchiemsee.

TYPICALLY BAVARIAN

Nowhere else in Germany is the juxtaposition of old and new so brazen. Ancient pilgrim traditions, once forbidden and later declared extinct, are more fervently practised than ever before. Although the reason for introducing the original customs, the plague, is now well behind us, Munich still performs its Schäfflertanz and Oberammergau its passion play. And take traditional Alpine dress, for example. Long mocked and ridiculed, more and more non-Bavarians are donning country casuals à la Dirndl and Lederhosen. National costume competes with haute couture in Munich, too, which is home to some of the country's most prominent and most eccentric fashion designers.

The contrast between traditional crafts – such as the glass blowers of the Bavarian Forest, the potters of Dießen and the box makers of Berchtesgaden – and international concerns Siemens, MAN and BMW is no less crass. Munich, one of the most significant centres of the economy in Europe, not only has industry and banks to offer but also science, art and culture. The varying focus of the many Bavarian regions alone guarantees a broad spectrum of interest. The most

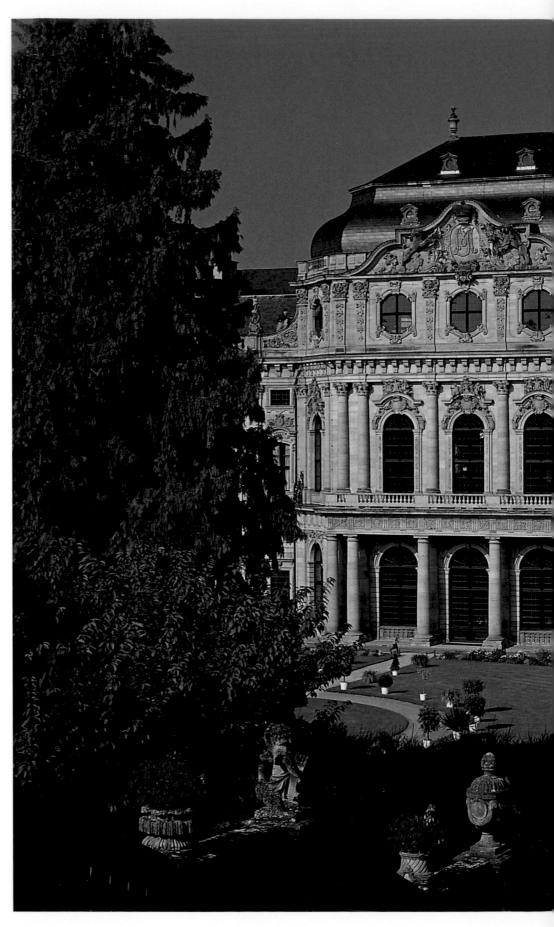

The Residenz in Würzburg, one of the most magnificent palaces of the baroque, is now a UNESCO World Heritage Site. No less than six prince-bishops worked on its construction under the auspices of one brilliant architect: Balthasar Neumann. Originally from the Egerland, Neumann was discovered and patronised by prince-bishop Johann Philipp Franz.

recent and vivid example of this is the Georg Schäfer Museum in Schweinfurt exhibiting the famous industrialist's top-class collection.

There are plenty of typically Bavarian witnesses to the present such as these, ones which look to the future while being rooted in the past, parables of small beginnings and great metamorphoses. One of the best-known tales of success is undoubtedly that of the little workshop in Dingolfing where Hans Glas repaired tractors; this later became the Bayerische Motoren Werke. Perhaps the most moving story of all, however, centres on the son of a glassmaker from Straubing, Joseph Fraunhofer (1787–1826), who made pioneering discoveries in the field of physics and optics – with no academic education whatsoever.

PARADISE ROAD THROUGH THE ALPS

It's possibly the general diversity of modern-day Bavaria – the landscape included – which has made the state the number one holiday destination in Germany. The Deutsche Alpenstraße (German Alpine Route) is the best way to explore the south of the country's most mountainous province. It links the foothills of the Alps to the no less fascinating watery world of the Upper Bavarian lakes.

It doesn't really matter if you begin your journey in the east or west of the state. If you prefer to do things step by step, then save the magnificent Königssee in the Berchtesgaden Alps till last and start out at Lindau. From this town on the Bavarian shores of Lake Constance you have grand views of your first port of call, the Allgäu Alps with the 2,224 metres (7,297 feet) of the Nebelhorn rising up in front of you. Past Hindelang it's well

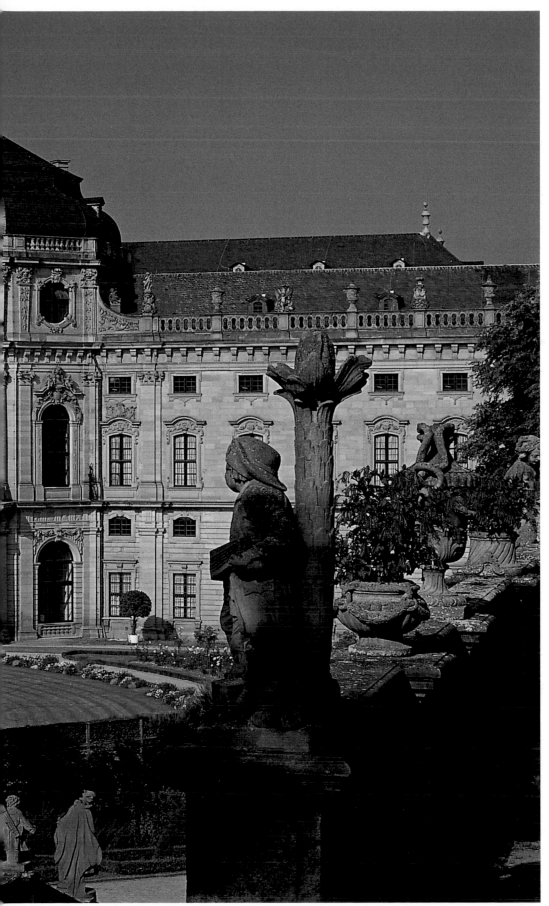

worth taking a minor detour to Oberjoch. The road seems to be one hairpin bend after another; you have to search long and hard elsewhere in Germany to find a(n accessible) stretch as excitingly precipitous as this.

The many beautiful sacred buildings of the Pfaffenwinkel region (literally: »parson's place«) are surpassed by the splendid pilgrimage Wieskirche, now a UNESCO World Heritage Site. Not far from this giddily stuccoed Rococo gem are the next attractions on the itinerary, the royal palaces of Neuschwanstein, Hohenschwangau and Linderhof.

The heart of the Bavarian Alps is the Werdenfelsener Land with the former Olympic venue of Garmisch-Partenkirchen and the Zugspitze. Here, atop Germany's highest snowy peak, you can almost touch the (not infrequently) blue sky 2,963 metres (9,721 feet) above sea level. Past the Karwendel range the road winds on to the valley of the Tegernsee, where the scenery, climate and healing waters of Bad Wiessee guarantee a healthy constitution. If your thirst for works of art both natural and man-made has not yet been stilled, then hurry on to Bernried on Starnberger See. Here a new museum awaits with one of the largest and most valuable collections of Expressionist art, compiled by best-selling author Lothar-Günther Buchheim of »Das Boot« fame.

The next stop on our journey is the Chiemgau with the Chiemsee which the Bavarians – lacking a maritime port of their own – modestly call their »sea«. The lake does indeed cover a staggering 80 square kilometres (30 square miles) and when a violent Alpine storm whips up the water, the comparison is a fair one. From here it's not far to the Berchtesgadener Land and the spectacular terminus of the Deutsche Alpenstraße.

BAVARIA'S SWABIA

Like Franconia, the western part of the Swabian homeland only fell to Bavaria 200 years ago. Around 160 different estates – some so insignificant as to hardly qualify for such a grand denomination – were handed over to the Wittelsbachs. Among them, just 70 kilometres (43 miles) from Munich, was the 2,000-year-old city of Augsburg. Its long and prosperous past makes the Bavarian capital almost pale into historic insignifi-

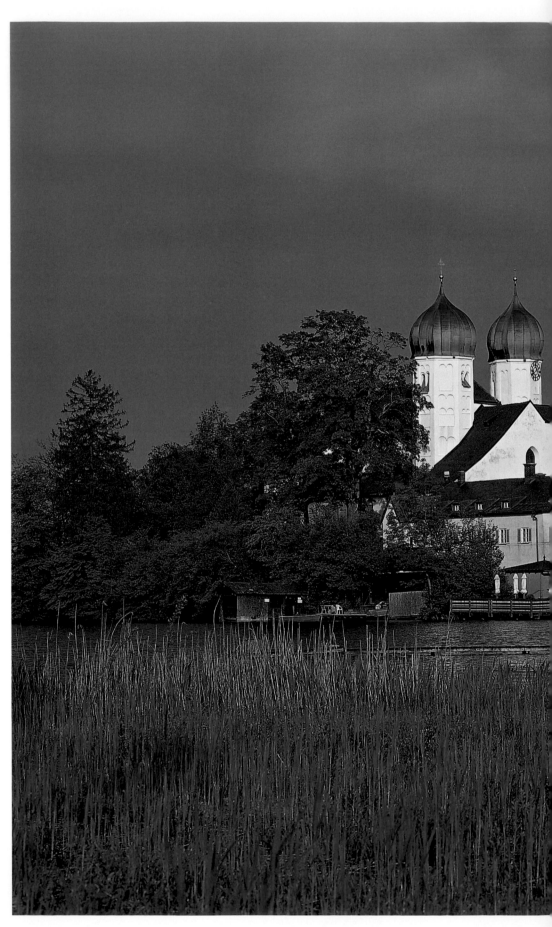

The Benedictines of Seeon not only ran a renowned scriptoria but also gradually cultivated the wilderness which surrounded their monastic home. In the once Romanesque Church of St Lambert's, now used by the local parish, are many beautiful epitaphs, among them the tombstone of Count Palatine Aribo who founded the monastery.

cance beside it. The latter has neither Romans nor early dynastic potentates such as the Welsers and the Fuggers to offer, who not only knew how to amass vast amounts of wealth but also how to bring kings and emperors into their debt, making them their dependants. With their calculating, forward-looking way of thinking – Augsburg was also an important protagonist during the Reformation, fighting to eradicate social injustice – it's hardly surprising that the extremely rich endeavoured to portray themselves as benefactors of the poor. In 1516 Jakob Fugger and his two brothers thus funded the first subsidised housing estate in the world, the Fuggerei, which is still fully functional.

Otherwise it's lucky the Swabians weren't around 15 million years ago; if they had been, they would have been obliterated by the giant meteorite which came careering down into Swabia, leaving behind the enormous Nördlinger Ries' crater. Germany would have then been a far poorer place without the thriftiness and keen sense of business usually associated with people from this area. And where would the spa industry be without Sebastian Kneipp, a failed priest from Wörishofen, who in true Swabian fashion used water – the cheapest healing commodity available – to great effect.

FROM MOUNTAINOUS FOREST TO THE BEAUTIFUL BLUE DANUBE

Where the Alps act as a boundary in the south, the Bavarian Forest or Bayerischer Wald – together with the more northerly Oberpfälzer Wald – forms the state boundary to the east. The largest and oldest area of forest in Europe was thought to be impenetrable for many, many years. The people who lived here kept themselves to themselves, their verdant prison providing them with

shelter, natural defences and food. It also supplied plenty of building materials and fuel to melt ore and later glass. And it was a loyal friend to them even in death, allowing the deceased to rest in state on wooden boards carved from its trees and erected under its leafy canopy or outside one of its chapels after burial – a tradition still practised in the remoter corners of the forest.

Otherwise much has changed here. Where for centuries the routes crossing the forest – among them the famous Goldener Steg – were few and far between, today there are plenty of roads providing access to the increasing amount of traffic commuting to and from the Czech Republic and to those who come here all year round to relax and fill their lungs with »Germany's cleanest air«. Since the 1950s, when reports of boarding houses with only one key for both kitchen staff and guests were not infrequent, much of the forest has entered the 21st century. Yet ironically enough it's this down-to-earth approach which holds a marketable appeal for the visitors who come here to enjoy the practically unspoilt scenery. The 25,000 hectares (ca. 61,700 acres) of the Bayerischer Wald National Park are also a great attraction, where bears, wolves, lynx and bison have been reintroduced and happily coexist alongside their human neighbours.

Lower Bavaria is not all forest, however. The Danube also characterises the region, with wide, fertile water meadows lining its banks. The heart of »old Bavaria« beats in Straubing in time to the chiming bells of the splendid baroque monasteries and churches of Metten, Niederaltaich and Osterhofen-Altenmarkt which surround it.

The Danube also links two very different Bavarian cities with one another. Regensburg, seat of the Perpetual Imperial Diet for one and a half centuries and thus to all intents and purposes the capital of the Kingdom of Germany in the Holy Roman Empire, is proud of its history. No less than 20 medieval landmark towers, aristocratic, Tuscan-style high-rises, shoot up towards the heavens. Things become even more Mediterranean in Passau to the south, where architects, artists and ornamental plasterers from Upper Italy and Tyrol have introduced the colours, shapes and styles of their native regions to their northerly clients. Passau also boasts six Italianate promenades along three rivers: the Danube, Inn and Ilz.

19

Burghausen, the oldest royal seat in Lower Bavaria, is dwarfed by the largest and best-kept castle in Germany. The original complex from the 13th century has been continually extended and is now over one kilometre long. The castle has good views out over the medieval old town whose brightly-painted houses smack of the Mediterranean.

»HAVE A FRANK AS A FRIEND, BUT NEVER AS YOUR NEIGHBOUR«

Maybe Bavaria had this Roman proverb in mind when at the beginning of the 19th century it placed the patchwork quilt that was Franconia, taken apart and pieced back together so many times, firmly within the confines of its own chambers, solving the problem of the troublesome neighbour once and for all. Franconia's turbulent history at least had a happy end; four ecclesiastical principalities (Würzburg, Bamberg, Eichstätt and the estates of the Teutonic Order), two margravates (Ansbach and Bayreuth), a bevy of counties (including Henneberg, Schwarzenberg, Hohenlohe and Wertheim), five free imperial cities (Nuremberg, Schweinfurt, Rothenburg, Weißenburg and Windsheim), six Franconian cantons and a handful of self-governing villages were united as a whole, with each retaining many of its own particular characteristics and peculiarities. A historic treasure-trove awaits modern-day visitors to Franconia, its riches spread out between the three administrative districts of Upper, Middle and Lower Franconia.

The Upper Franconian administration sits in Bayreuth – which it has to share with Richard Wagner during the famous festival. In contrast to the deafening warblings of Wagner's Valkyries, the silent spirit of Margravine Wilhelmina, Frederick the Great's favourite sister, quietly lives on in the glorious palaces and gardens nearby. Bayreuth lies at the foot of the Fichtelgebirge which together with the Franconian Forest girdles the northern end of Upper Franconia. This natural fortification has been strengthened in Kronach and Coburg by two mighty bulwarks of human design. The sacred counterpart to these martial edifices is the imperial cathedral in Bamberg, one of the most important works of medieval architecture in

Germany and now a UNESCO World Heritage Site together with the old town surrounding it.

The cathedral in Bamberg is to the Upper Franconians what the imperial castle in Nuremberg is to the Middle Franconians. Up until the 16th century it was one of the most popular abodes of the German royal household. Trade and crafts flourished, with the arts also profiting from the city's steadily accumulating wealth. Albrecht Dürer, Adam Kraft and Veit Stoß were either native Nürnberger themselves or added to its riches invaluable works of their own. The entire historic quarter of Nuremberg was sadly bombed into oblivion during the Second World War and had to be painstakingly reconstructed; Rothenburg ob der Tauber, on the other hand, was spared and can boast the originals. This medieval marvel, right out of a children's picture book, is famous the world over.

Although Würzburg suffered the same terrible fate as Nuremberg, its most beautiful and important buildings – such as Balthasar Neumann's many churches and Marienberg Fortress – again bask in their former glory. It's not just the Lower Franconian cities of Würzburg and Aschaffenburg which effuse a certain charm; its many sleepy towns and almost Mediterranean villages are also enchanting, lazily sprawled along the banks of the Main or tucked away in the beech forest of the Spessart or the mountains of the Rhön.

Page 22/23:
Against a fantastic Alpine backdrop like this one in the Werdenfelser Land, skiing has just got to be fun. This particular run circles the Geroldsee, with the Karwendel Mountains glittering in the background.

Page 24/25:
As in many of the towns and villages in Franconia Ochsenfurt boasts a bevy of pretty half-timbered buildings. In 1927 the little town on the River Main went down in the annals of literary history as the site of Leonhard Frank's best-selling novel »Das Ochsenfurter Mannerquartett« (The Singers).

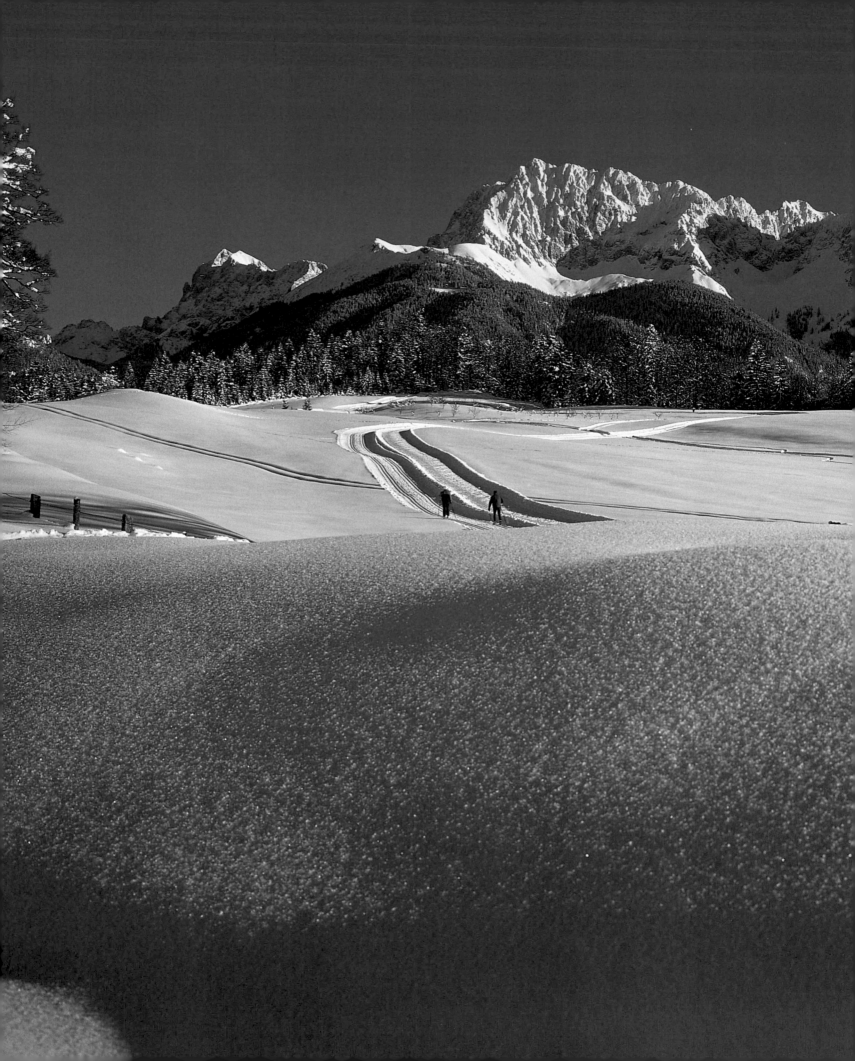

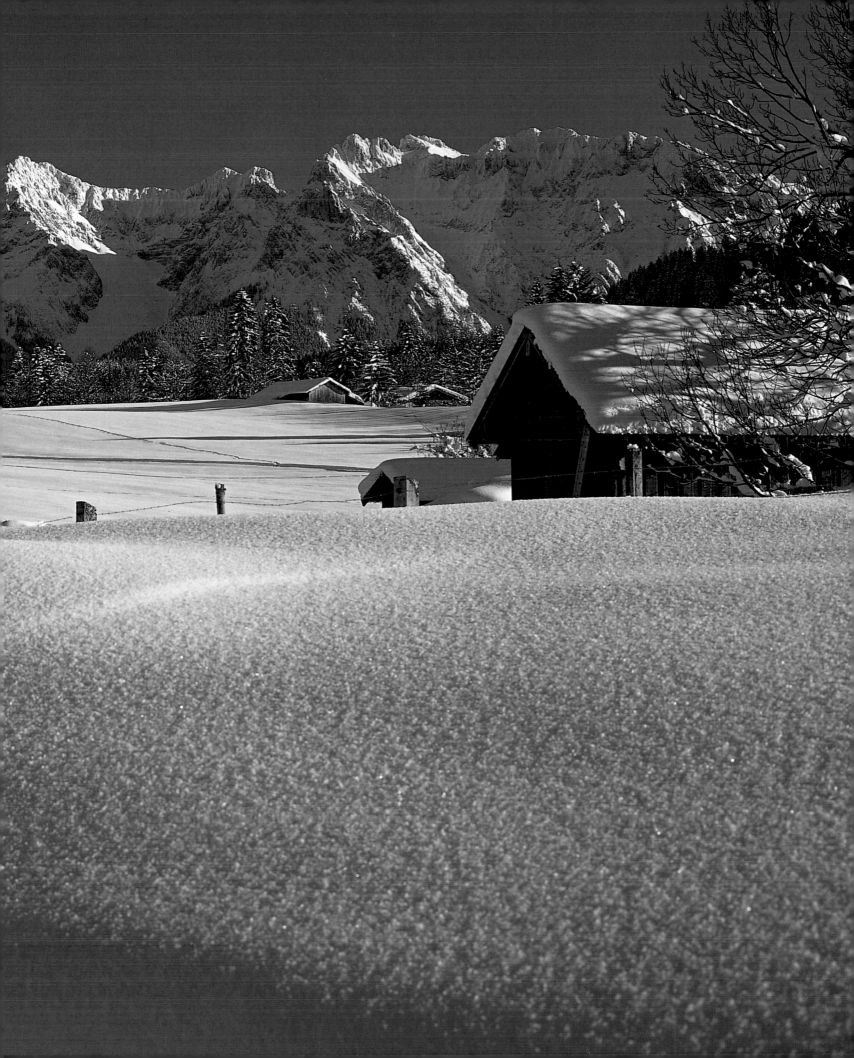

ZUM SCHMIED

1268

Die Sage raunt
Ein altes Lied
Hier hausete
Hans Stock
Der Schmied

anno 1268

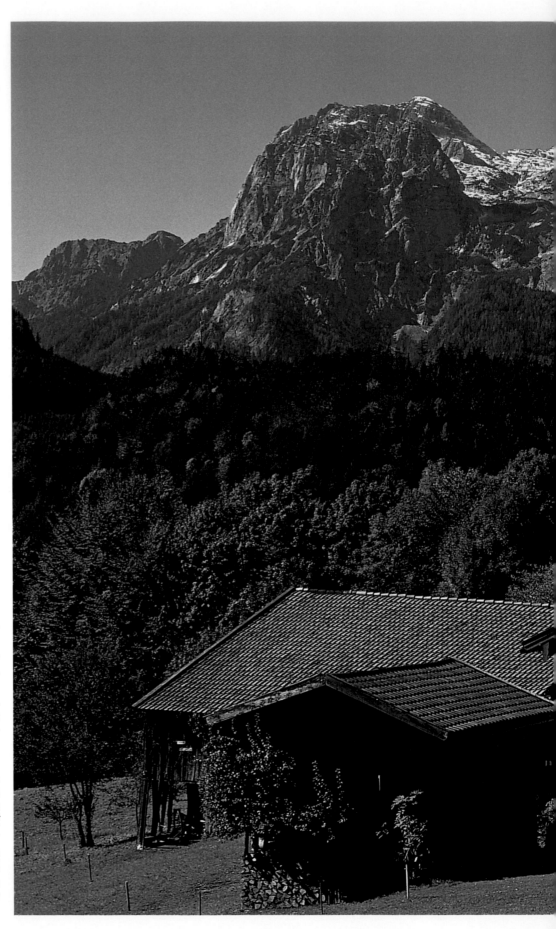

Ramsau near Berchtes-gaden is popular for both its healthy climate and excellent range of mountain walks. The more strenuous of these lead up into the Reiter Alpe, on past the stables and sunny window boxes of Freidlinglehen farm-house.

Together with Lower Bavaria Upper Bavaria is one of the heartlands of the old Bavarian stem duchy and at ca. 17,500 square kilometres (ca. 6,760 square miles) in area its largest administrative district. Its territories and almost 4 million inhabitants cover around one quarter of the free state.

To the south the Alps create a natural, magnificent border. During the Ice Age the glaciers slid down into the foothills, in time forming the beautiful Upper Bavarian lakes. Five of them, very close together, make up a veritable Bavarian lake district: Ammersee, Wörthsee, Pilsensee, Weßlinger See and Starnberger See. The latter is something of a local lido for the people of Munich and prac-tically on their doorstep.

Around 1.3 million inhabit the Bavarian metropolis; many more would like to live here. Munich is the most attractive city in Germany – and also one of the most expensive. The investment is well worth it, however, as life in Munich has all the qualities one would expect, plus a distinct charm, certain no-blesse and friendly warm-heartedness. Even those who think they know Munich well are surprised to discover it anew each time they come here.

It wasn't until the beginning of the 19th century that Bavarian Swabia was annexed by old Bavaria. The enormous meteorite Ries crater marks the northern boundary of the region, which continues as the Upper Danube Valley, punctuated by popular urban gem Augsburg, Bavaria's first major city, and reaches its giddy climax with the four dozen or so Alpine peaks of the Lower and Upper Allgäu.

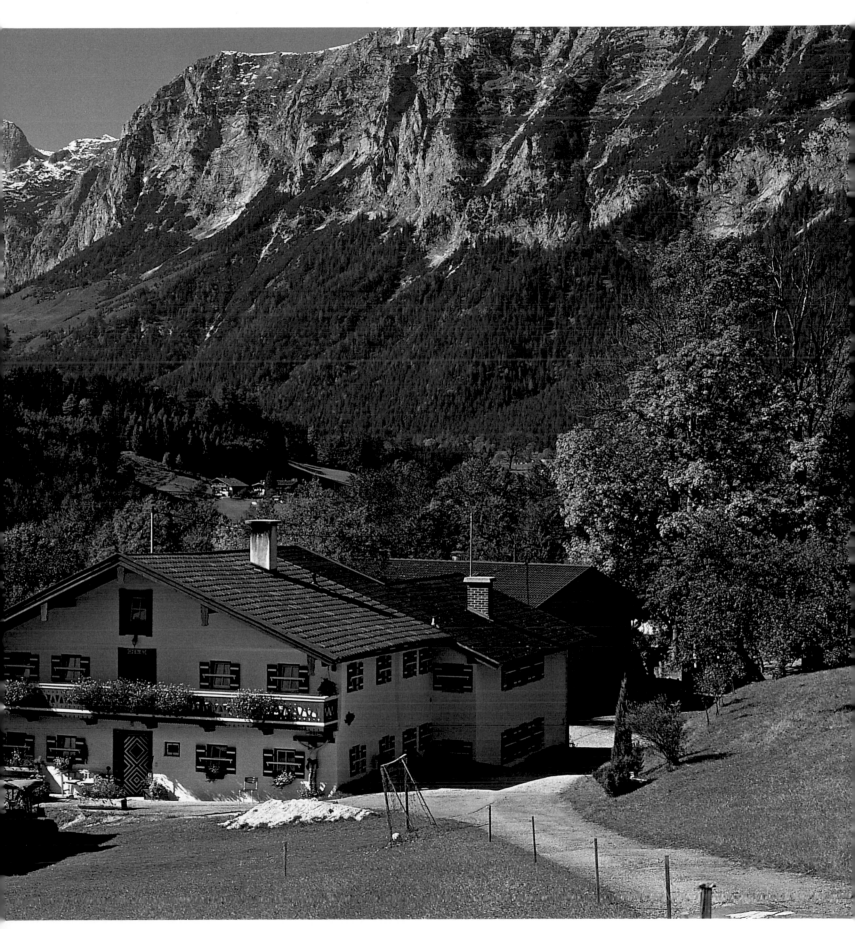

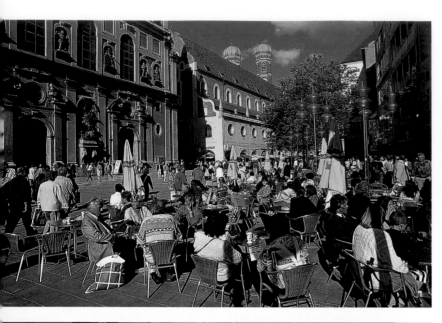

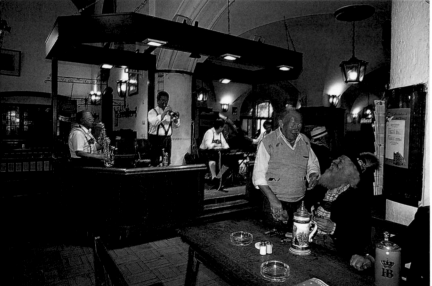

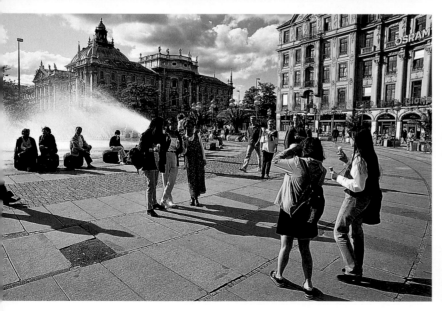

Top left:
Neuhauser Straße and Kaufingerstraße make up the heart of Munich's main shopping axis. After trawling the many famous stores, the outdoor cafés are a welcome respite where you can sit and watch the world go by.

Centre left:
Munich's Hofbräuhaus is famous not just for its beer but also for its oompah bands and gutsy waitresses. Possibly the

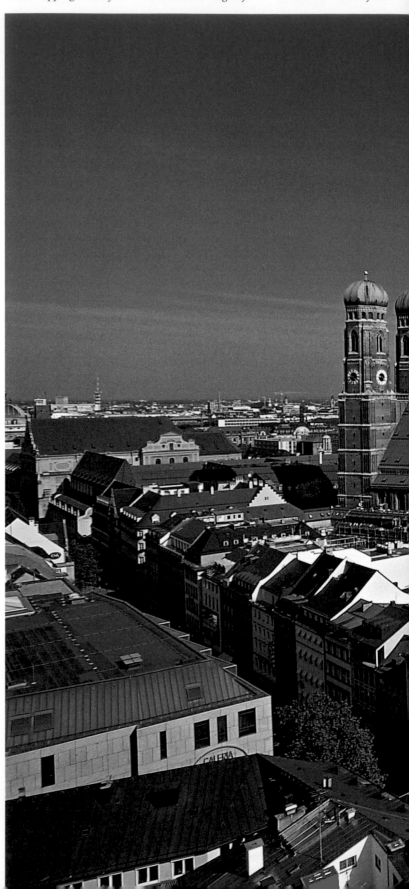

city's (if not Germany's) best-known pub, it's guaranteed to pull the crowds and is often full to bursting, seating 2,500 at peak capacity.

Bottom left:
Munich's Karlsplatz was laid out in 1791 after the city defences were torn down by Karl Theodor, after whom the square is named. The elector was not particularly popular with his citizens, hence the local name Stachus, still used today.

Below:
The oldest parish church in town is affectionately known as »Old Peter« and had to be completely rebuilt following heavy bombing during the Second World War. From the spire you have fantastic views out over the city with the town hall and Frauenkirche.

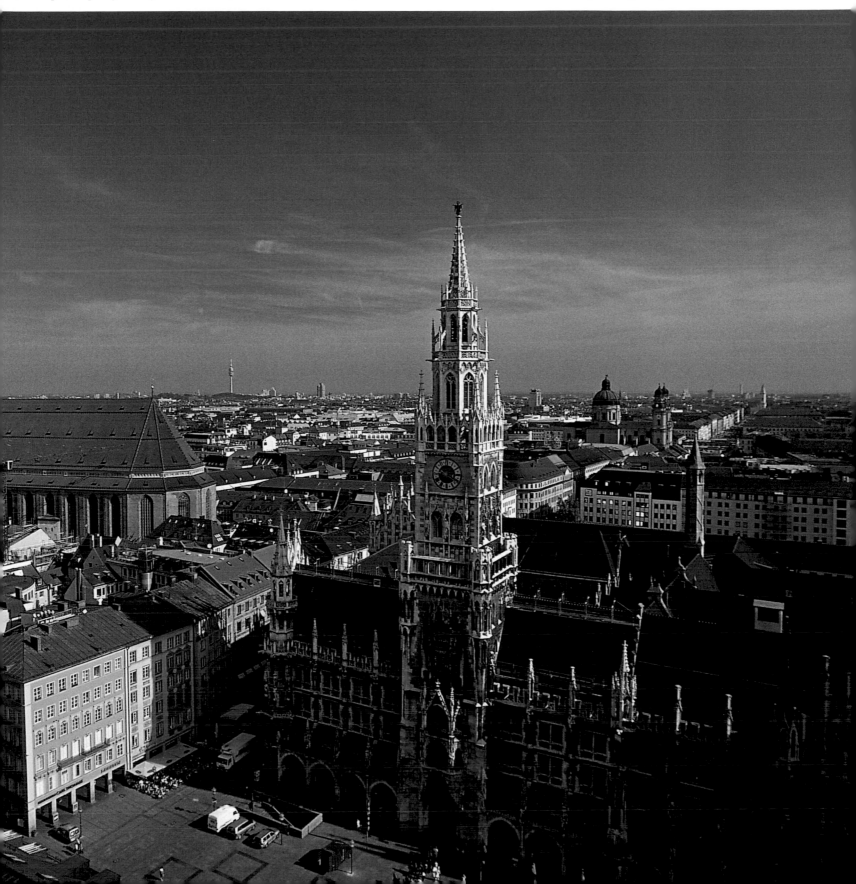

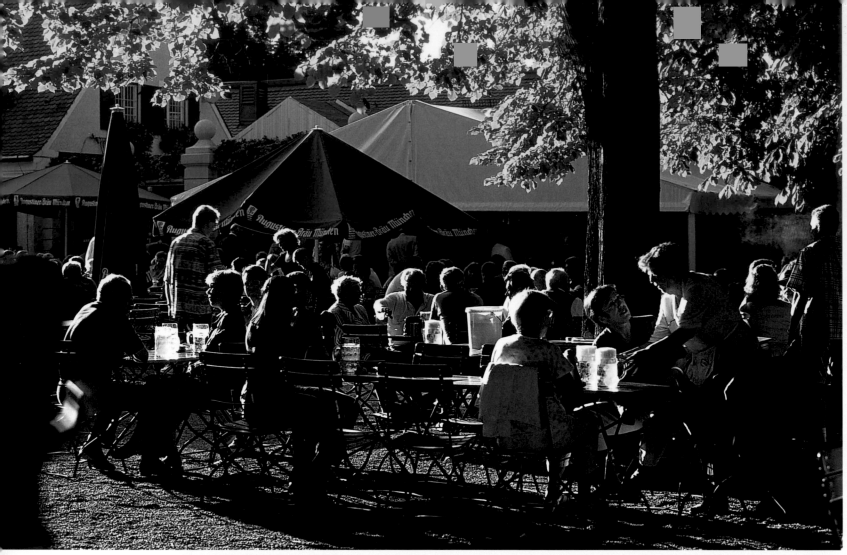

Above:
Where would Munich be without its beer gardens? Serving Germany's beloved beverage straight from the cellar where it's stored has proved extremely lucrative over the years. To keep the barrels at a palatable temperature (cold) chestnut trees are often planted in the brewery yard – such as here at Munich's Hirschgarten.

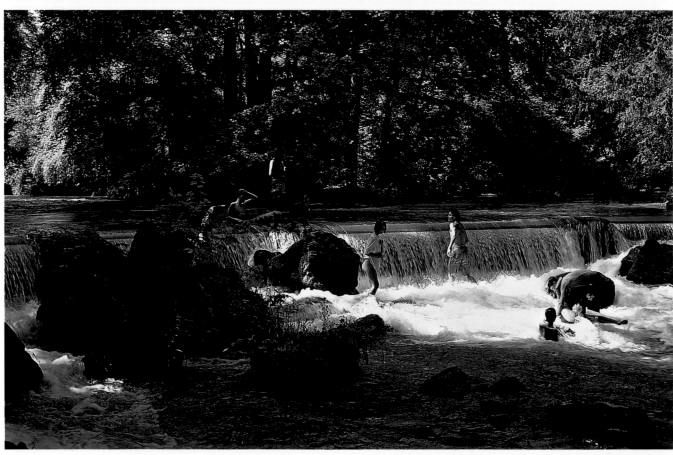

Right:
Munich's English Garden is the largest inner-city park in Germany. It's also a great place to relax and engage in all kinds of outdoor activities, such as swimming and paddling in the Eisbach river.

Left:
Among the architectural monuments in the English Garden is the Monopteros, a neo-classical, temple-like structure built between 1837 and 1838 by Leo von Klenze on a hill especially constructed for the purpose.

Below left:
Even though much has changed here, Munich's Viktualienmarkt still has its characters and originals à la Karl Valentin, in whose honour a bronze fountain has been erected.

Below right:
After some serious shopping at the market you may be in need of sustenance – for which purpose there's a conveniently large and inviting beer garden.

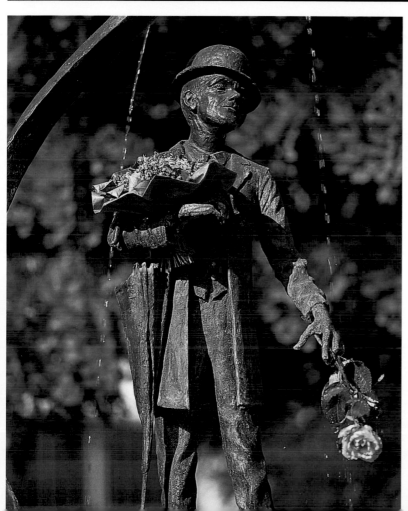

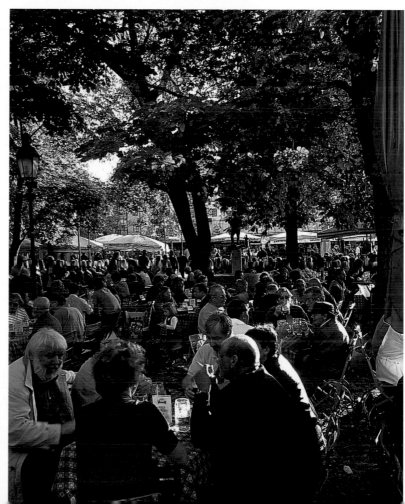

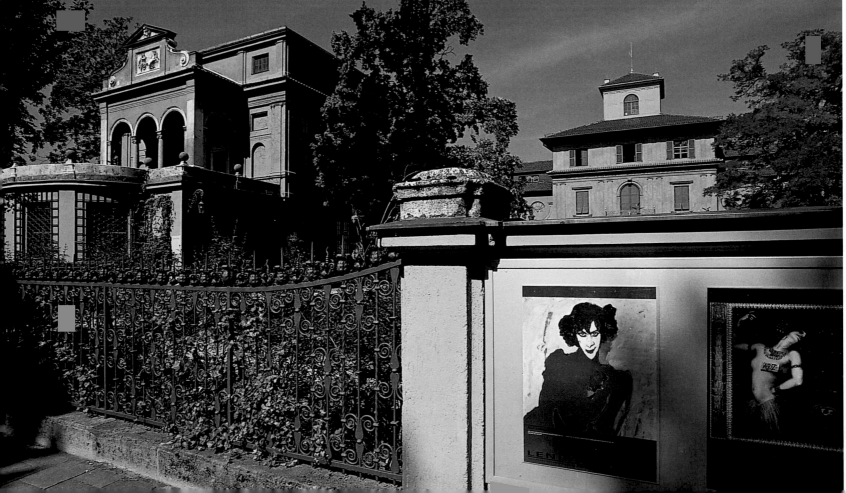

Left:

The Deutsches Museum was founded in 1903 on an island in the River Isar. It houses one of the largest scientific and technical collections in the world. One of its more popular sections, installed in 1992/93, is the Forum of Technology with its IMAX cinema and Space Theatre.

Left:

The Deutsches Museum was founded in 1903 on an island in the River Isar. It houses one of the largest scientific and technical collections in the world. One of its more popular sections, installed in 1992/93, is the Forum of Technology with its IMAX cinema and Space Theatre.

Below:

The Cathedral of Our Lady in Munich – usually referred to as the Frauenkirche – was built in late Gothic brick in the second half of the 15th century. The roof is supported by 22 pairs of octagonal pillars.

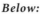

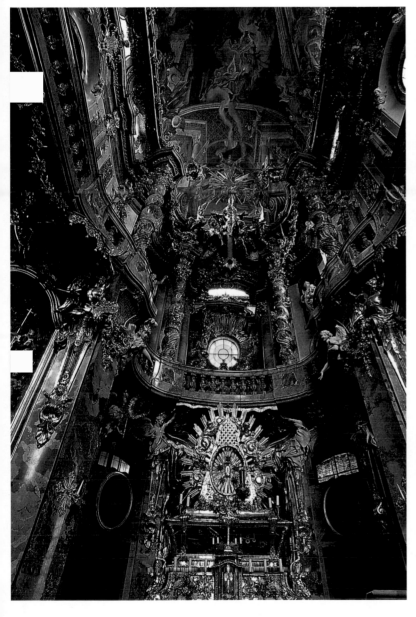

Left:

Franz von Lenbach was Munich's leading portrait artist during the late 19th century. His magnificent neo-Renaissance villa is a testimony to his princely earnings and since 1929 has accommodated the Städtische Galerie or municipal art gallery.

Above:

Of the many churches the Asam brothers designed and built in Munich alone, the opulent edifice on Sendlinger Straße is the most famous. Built between 1733 and 1746 and bearing their name, restoration of the magnificent interior was completed in 1982.

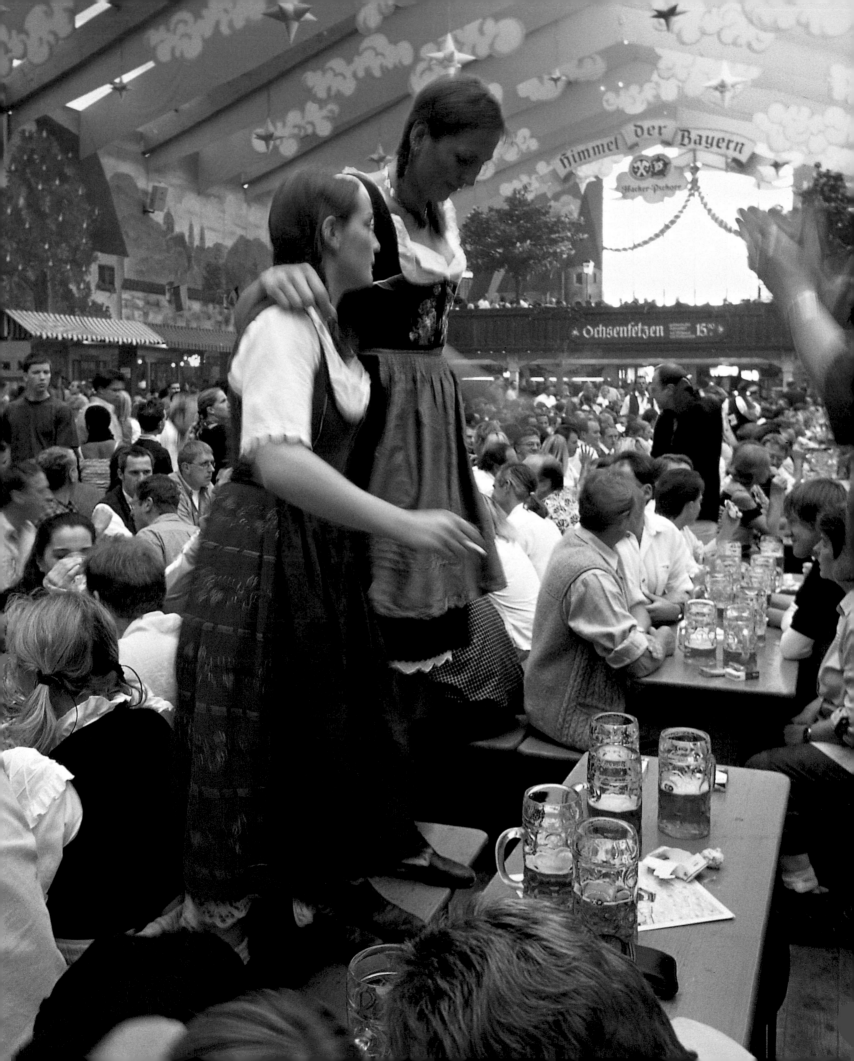

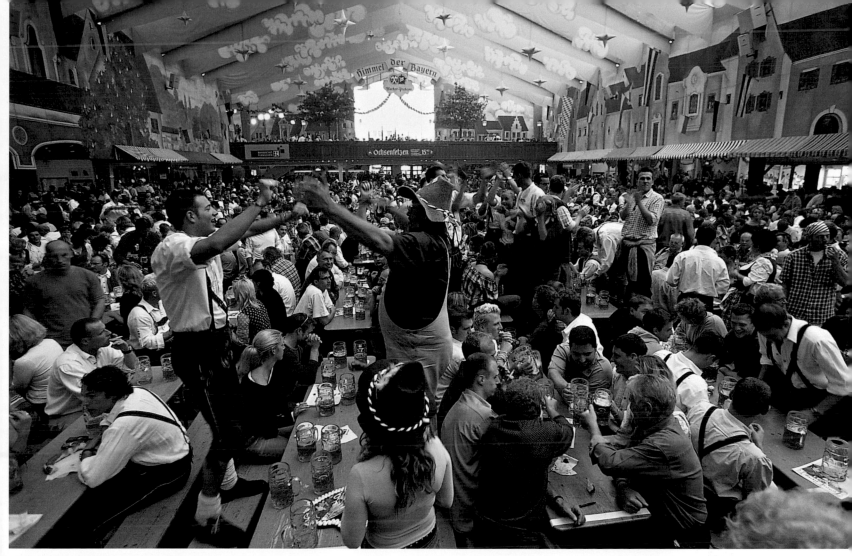

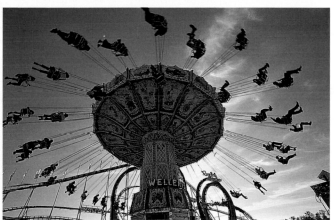

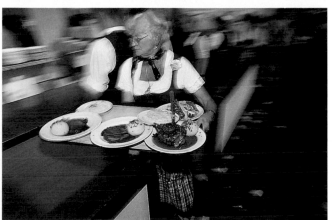

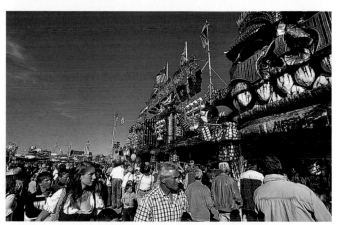

Above:
The marquees seem to get bigger and more comfortable each year, with long rows of tables and benches seating an enthusiastic host of (mostly inebriated) festival-goers.

Left page:
Beer tents are one of the major requisites of the Oktoberfest, enabling visitors to enjoy a litre or two (or three or four...) come rain or shine.

Small photos, left:
Half the world homes in on Munich at Oktoberfest time to join the merry throng savouring both beer and fairground. The less intrepid will be pleased to spot the good old merry-go-round among the many positively mind-blowing contraptions.

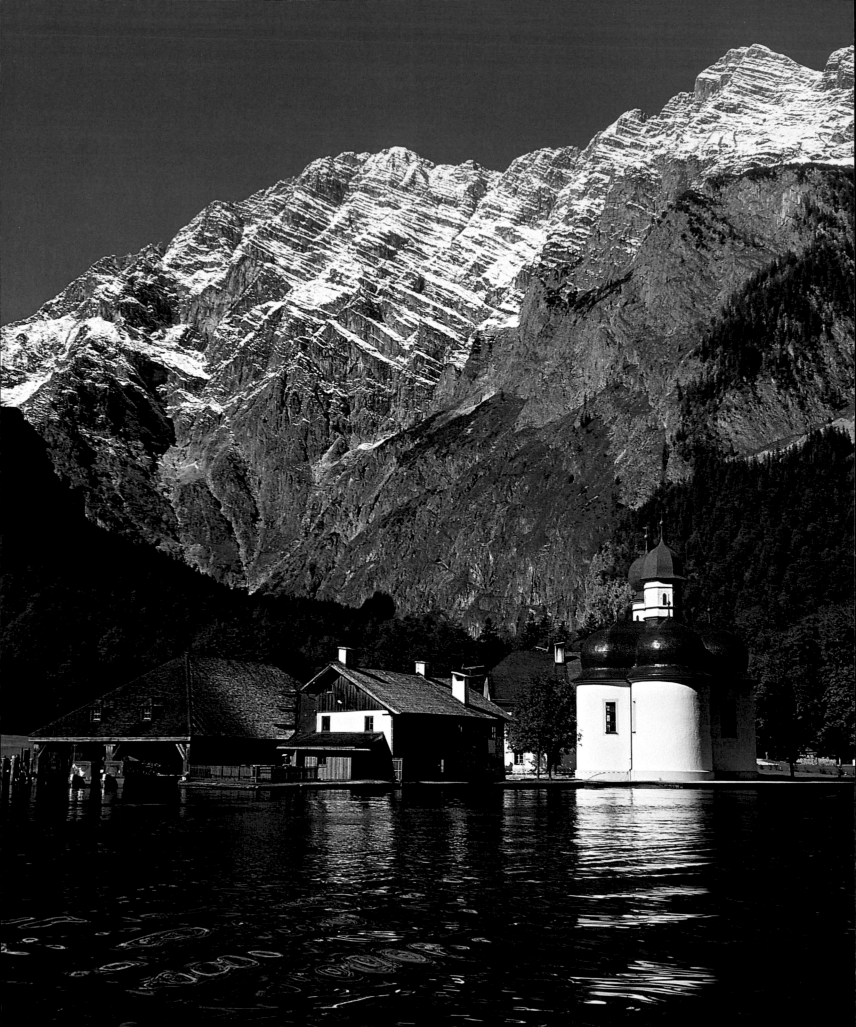

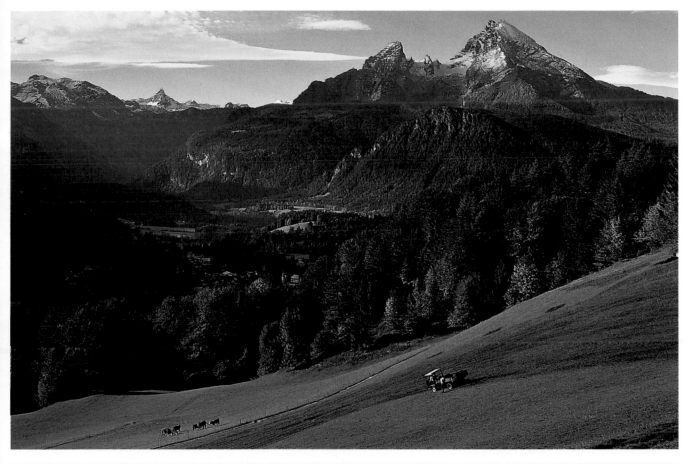

Left page:
Before the advent of photography the fantastic views out over the Königssee were captured in oil on canvas. Beyond St Bartholomä rises the gigantic east face of the Watzmann, one of the most challenging ascents in the eastern Alps.

Past the little chapel of Maria Gern north of Berchtesgaden a moun tain trail leads on up to the Kneifelspitze 1,200 metres (3,937 feet) above sea level. From the top there are marvellous views of the nearby Watzmann.

Alpine cows in the Rupertiwinkel nervously eye the camera. The lands they graze – namely Teisendorf, Waging, Laufen and Tittmoning – originally belonged to Salzburg, falling to Bavaria in 1810. The area is named after St Rupert who lies buried in Salzburg Cathedral.

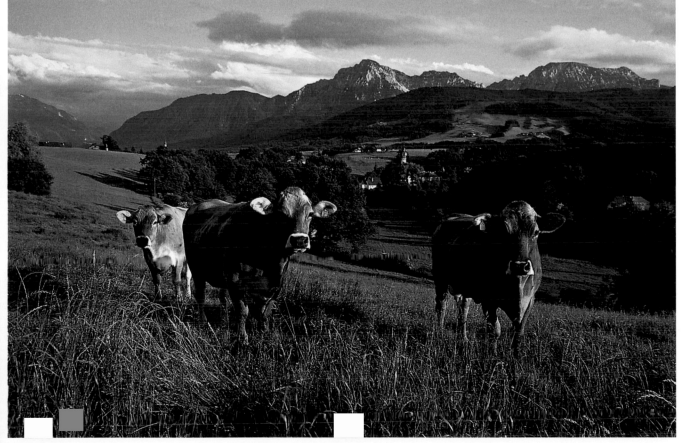

MILK AND CHEESE

What if...?« is one of those idle questions to which the answers are numerous, diverse and often beyond the bounds of our imagination. What if, for example, Swiss cheesemaker Johann Althaus hadn't come to the Allgäu in 1827? What if he hadn't brought that magic Swiss formula with him, the recipe for turning simple milk into delicious rounds of golden cheese? »Impossible!«, the average German would reply. »The Allgäu without cheese?! That's like Holland without Edam and Gouda, France without Camembert and Brie. No way!«

Sweeping all hypotheses aside, Althaus's product must have been pretty convincing, for the locals ploughed up their fields of flax en masse and turned their respective hands to dairy farming. Like the method, the chief suppliers to this new-found profession, namely those legendary brown Alpine cows

retted, dried, crushed and beaten flax, it now tended and milked cows, heated milk, formed curd and matured cheese. Flax farmers became livestock owners, day labourers found work as shepherds and the blue hues of the fields paled to the verdant green of the Allgäu we know and love today.

THE ALPINE PASTURE – A PLACE OF ROMANTIC FANCY?

The Allgäu is cherished for both its beautiful country and local produce – not just cheese but also milk and butter. There are around 400 types of cheese made here with over double that amount of flavours; nowhere else in Germany is so much of it manufactured as here in the Allgäu. Despite this generous variety and the occasional new creation, it's surprising that for years the all-

Left:
Basking in the sun on the Längentalalm in the Isarwinkel, you can't fail to agree with the old saying that milk and cheese taste better at source than anywhere else...

Below:
Top-quality raw materials, careful processing and time are the chief ingredients of a good

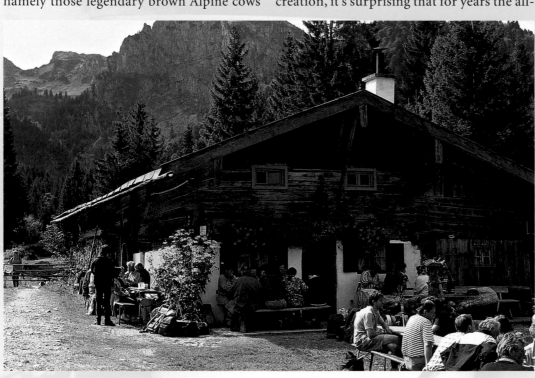

with their gentle eyes, prolific milk production and easy maintenance, also had to be imported from Germany's Swiss neighbours.

With the arrival of the cow in Bavaria a new chapter dawned in the milk and cheese industry north of the Alps. Travellers – of whom there were few and far between in those days – were astonished to watch the landscape change colour. Gone were the fields of blue flax; the lush green meadow was here to stay. Where the countryside had

time consumer favourite has been (and probably will remain) Emmentaler. Around 14 litres (25 pints) of milk are needed to produce one kilo (2.2 pounds). That's about the amount of milk one cow can produce in a day – if the pastureland is suitable, as it is here. Tending the meadows is the job of dairymen and women and no easy task. Despite knowledge to the contrary their way of life is still popularly depicted as one big idyllic myth. Even after seeing the unwel-

FROM THE ALLGÄU

cheese. These rounds are being matured at the Weizern cheese cooperative in Eisenberg in the east Allgäu.

Top right:
Allgäu is often called »the land of happy cows« – a marketable if rather twee designation which lauds the excellent production and quality of the region's milk.

Bottom right:
Another maxim of Allgäu cuisine is that where the best cheese is made there are also the best Käsespätzle, plump

noodles baked in cheese. Another typical dish is Baunzen (plate on the right), fingers of potato pasta dough fried in hot fat.

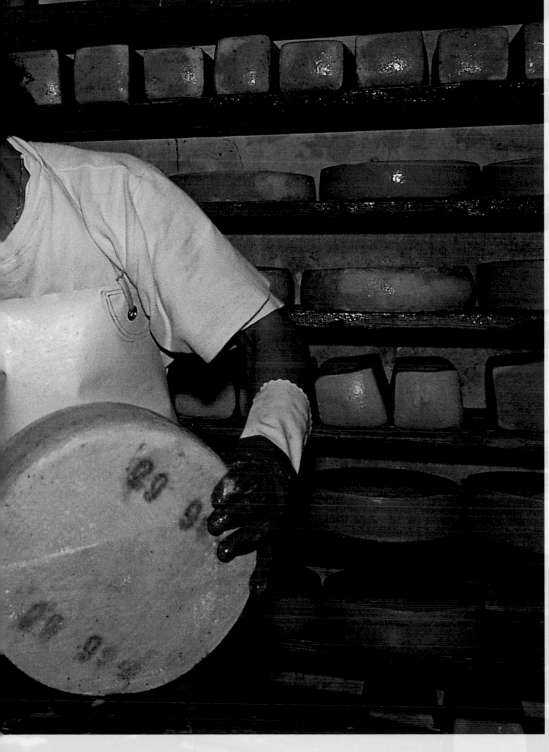

coming interior of an Alpine hut or watching the farmers hard at their back-breaking work, tourists still think that life on the edge of the Alps is one of fun and frivolity, with all kinds of erotic pleasures into the bargain. Maybe the increasing coolness of our society cries out for an escape such as this, a place of romantic fancy which our imagination does its utmost to preserve.

Admittedly much has changed. Where possible, milk and cheese are processed industrially. Mobile phones have done much to banish the dangers and loneliness of this often solitary existence. In many areas, however, Alpine dairymen still rely on the experience and tried-and-tested methods of their forefathers – and farm in accordance with the moon. Calves, for example, should only be weaned from their mothers where there's a full moon – but Heaven forbid not in the sign of Scorpio or Cancer. Tradition also advises keeping cattle away from Euphrasia officinalis or eyebright; also known locally as Milchdieb or »milk thief«, it's said to cause milk production to drop.

Yet life in the Allgäu isn't all hard work. Celebration is called for in autumn when the cows are brought down from their high-lying pastures. Both man and beast get dressed up for the occasion, trotting down the mountainside to the ringing of the village bells and the merry tunes of the local band waiting to kick off the well-earned party.

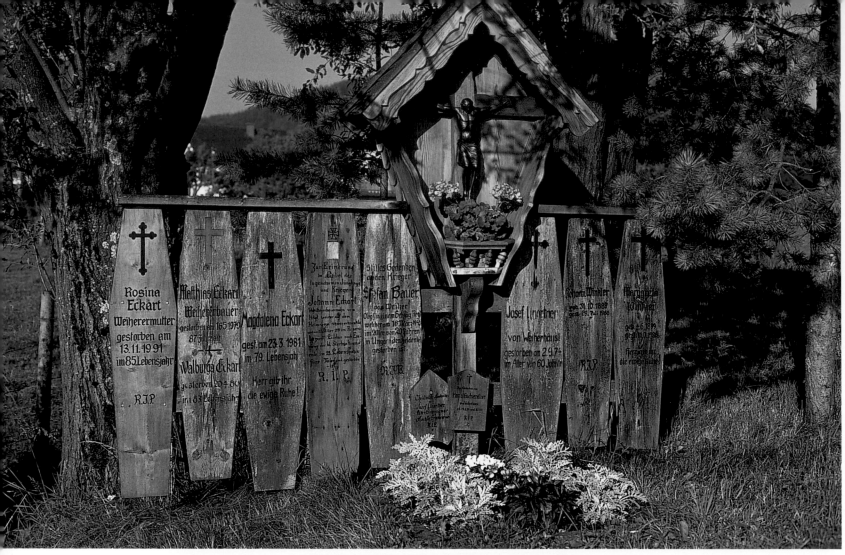

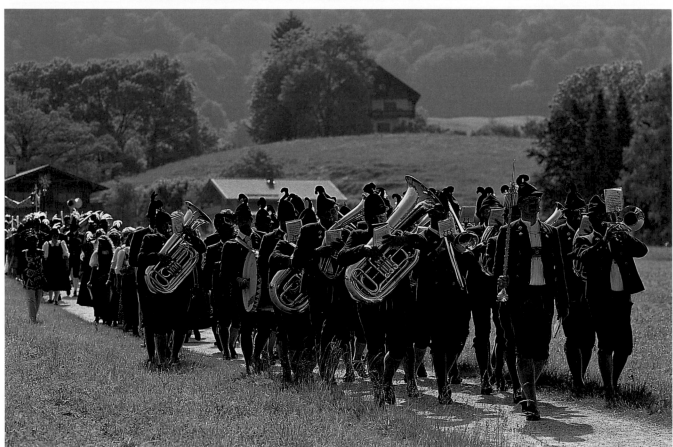

Above:
Inscribed panels at Weiherhof near Teisendorf. In keeping with an old tradition the boards on which the deceased are laid out prior to burial are later erected along the wayside in remembrance of the dead – and as a reminder to the living of their own mortality.

Right:
Ancient traditions live on in Upper Bavaria. At various parades for Corpus Christi, such as here in the Chiemgau Alps, the body of Christ is honoured as it has been since the 14th century. A cortege carries the consecrated Host to its destination in a monstrance on the second Thursday after Whitsun.

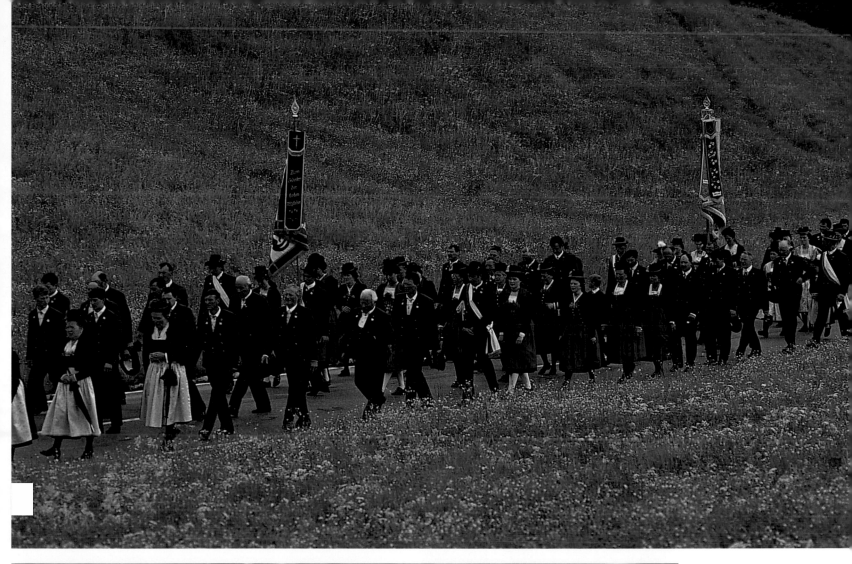

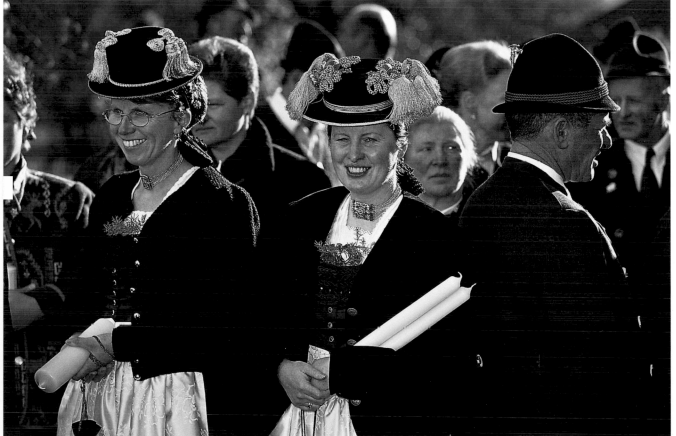

Above:
Particularly on special occasions, such as in honour of this pilgrimage to Maria Eck, the people of the Alps like to don traditional dress. Many of the clothes have been passed down the generations; modern replacements are a matter of time, money and lots of idealism.

Left:
Dedicating candles on St Leonard's Day in Rimsting. St Leonard is the patron saint of horses and cattle and in Bavaria alone has numerous churches and chapels named after him. November 6, his saint's day, sees a number of religious rituals performed in his honour.

41

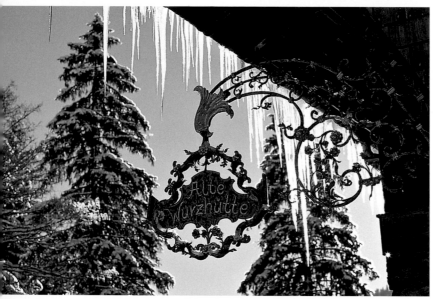

Top left:
The Toter Mann (dead
man) juts up from the
Berchtesgaden valley
basin like an island.

From its summit you look
straight out onto the
Hoher Göll, rising up
2,522 metres (8,274 feet)
into the heavens.

Centre left:
The Alte Wurzhütte on
Spitzingsee in the
Mangfall Mountains is
shrouded in ice in the

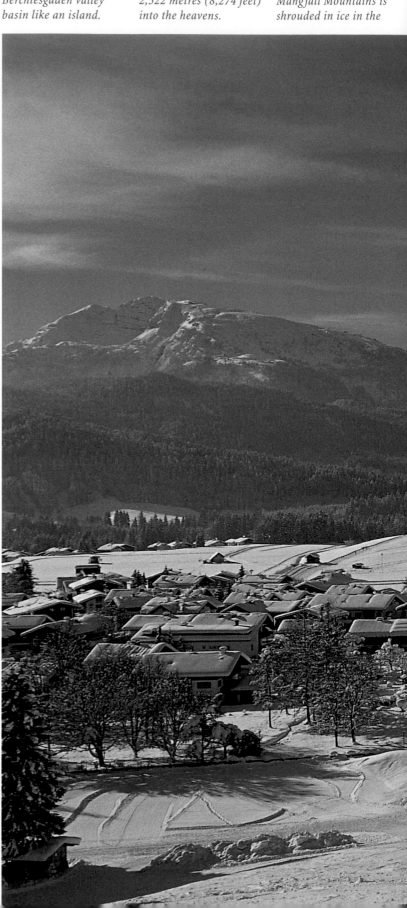

winter. The high-lying lake is the focal point of one of Bavaria's best skiing and tobogganing areas.

Bottom left:
In Wilparting the 18th-century pilgrimage chapel of St Marinus-

Anianus is dedicated to the two martyrs who lived and were laid to rest here.

Below:
Even if nowadays the winters seem to get shorter and warmer, Reit im Winkl on the Austrian border is still charted as the ski resort most likely to have the most snow in Germany. The best-known and most popular slopes are around Winkelmoos-alm where ski idol Rosi Mittermaier comes from.

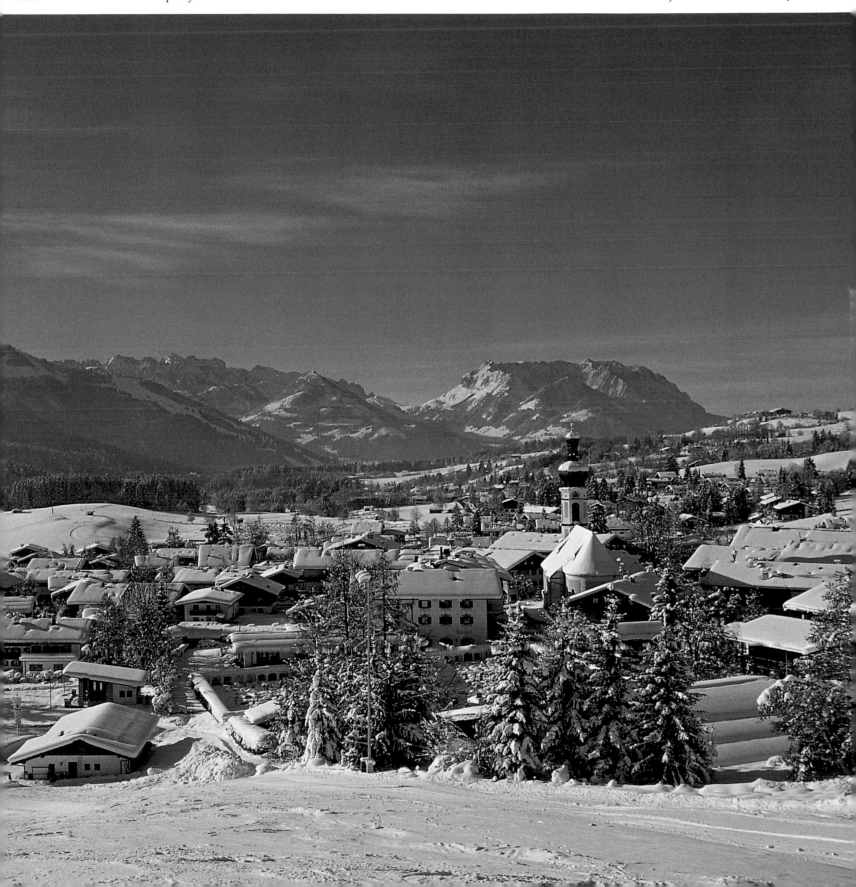

Right:

The Chiemsee, Bavaria's »sea«, is an absolute scenic and cultural high- light. As far back as the 8th century a convent and monastery were founded on two separate islands which are among the oldest historical sites in the land. Beyond the yachts and sailing boats is the spire of the Benedic- tine nunnery, seen here from the leafy shores of the Herreninsel.

Below:

King Ludwig II acquired the Herreninsel in 1873 for the erection of his version of Versailles. His elaborate plans were thwarted by empty state coffers and his untimely demise. Although it has remained unfinished, Schloss Herrenchiemsee is one of the biggest tourist magnets in the area.

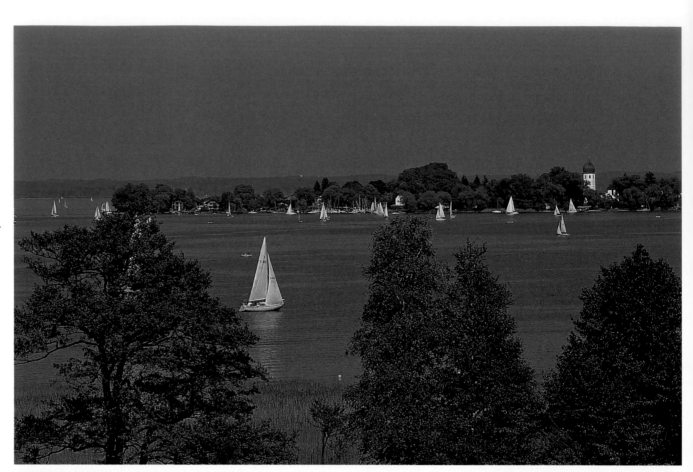

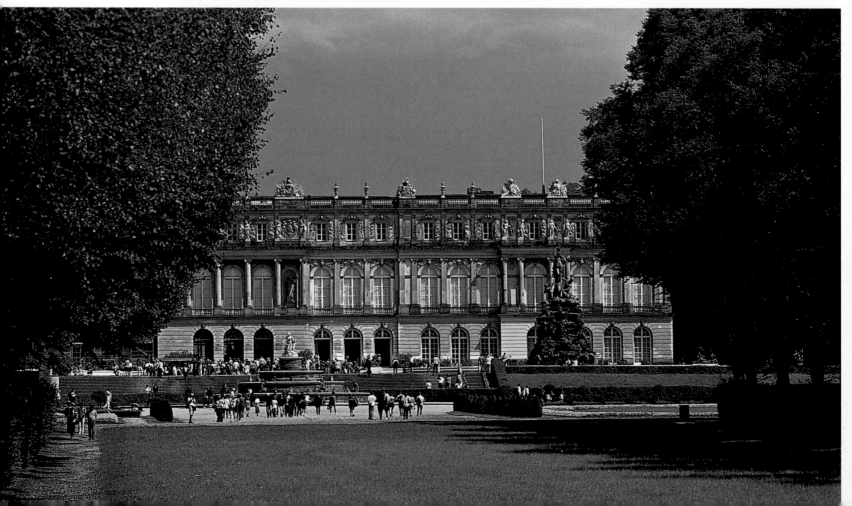

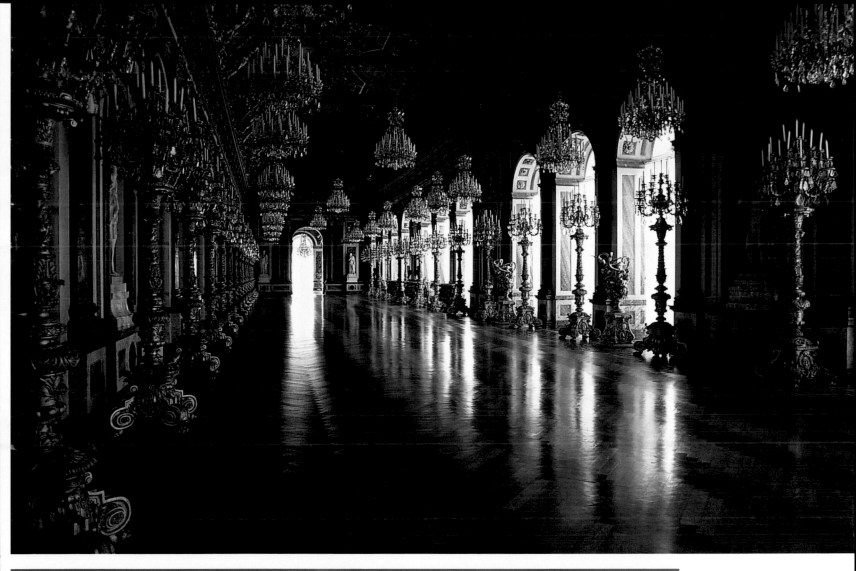

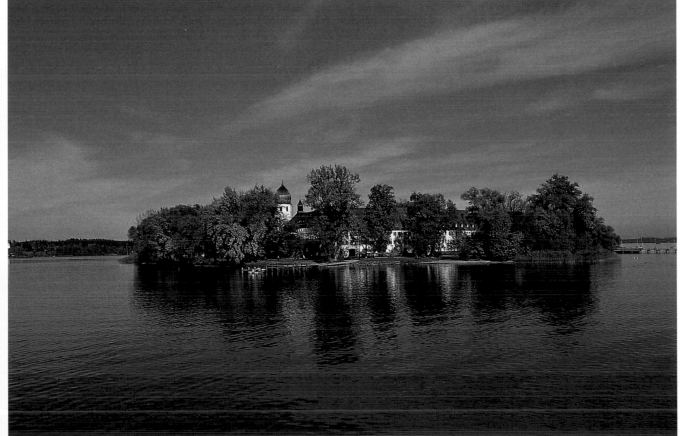

Above:
The entire interior of Schloss Herrenchiemsee pays homage to its great French counterpart. The mirrored gallery, installed between 1879 and 1881, is almost 100 metres (over 300 feet) long, surpassing the original at Versailles.

Left:
The idyll of the Chiemsee, with the Fraueninsel and its convent floating serenely on the still waters. The first abbess Irmengard, also the daughter of Ludwig the German, took up office here in 866; under her auspicious command the abbey also served as a royal palace.

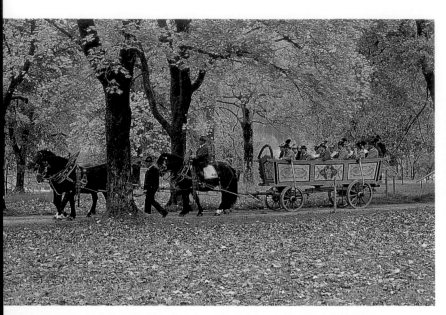

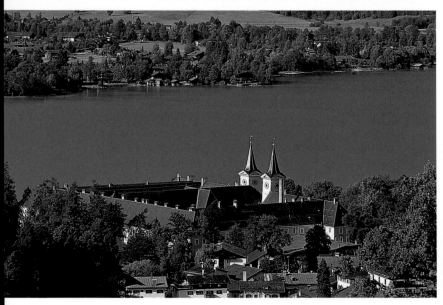

Top left:
On St Leonard's Day
worshippers set off for
church in Kreuth in the
Tegernsee Valley in a
horse-drawn carriage.

The church is revered as
the oldest shrine devoted
to St Leonard in Bavaria.
The tradition of the
Leonhardi-Ritt probably
also has its origins here.

Centre left:
Typical farmhouse in
Bayrischzell-Geitau.
Balconies run along the
front facade, cheerfully

adorned with window boxes of glorious summer pelargoniums and petunias.

Bottom left:
Rottach-Egern enjoys a marvellous setting at the point where the Rottach and Weißach rivers flow into the Tegernsee. The steeple of the parish church of St Laurentius dominates this autumn silhouette.

Below:
The village of Tegernsee grew up around the Benedictine monastery founded here in 746, which was to become one of the major players in the rich ecclesiastical and cultural history of Germany. Following secularisation the complex was turned into a palace fit for a king by the manager of the Hofbräuhaus, Leo von Klenze.

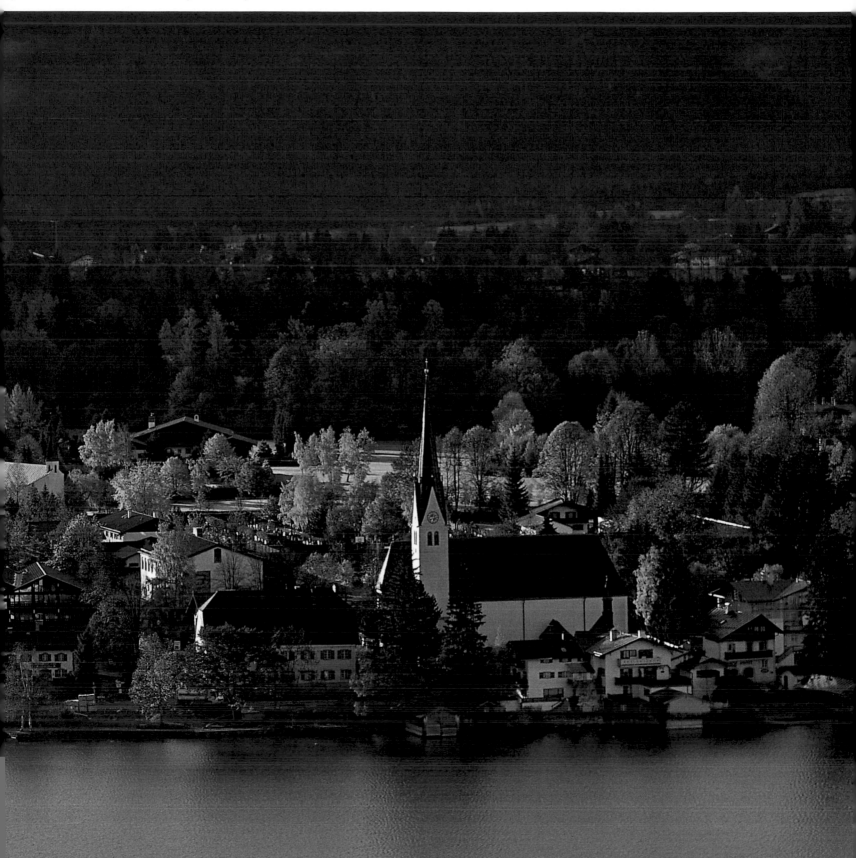

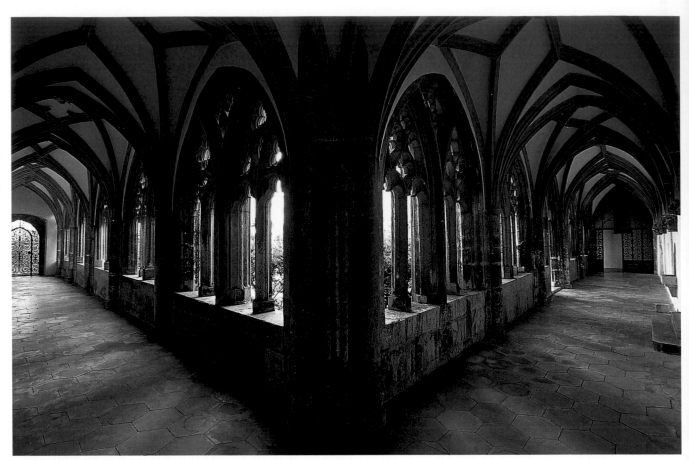

Right:
The cloisters of the cathedral in Eichstätt, dedicated to St Salvator, St Willibald and the Virgin Mary, were laid out in the late Gothic period. The church itself is an aisled pillared hall from the second half of the 14th century, built on the foundations of earlier places of worship.

Below:
Kapellplatz forms the nucleus of Altötting, the most significant place of pilgrimage in Germany. To the left is the Church of St Magdalena and on the right is the parish church. Tucked away between them is the tiny octagonal chantry chapel from the 8th century with its more recent nave.

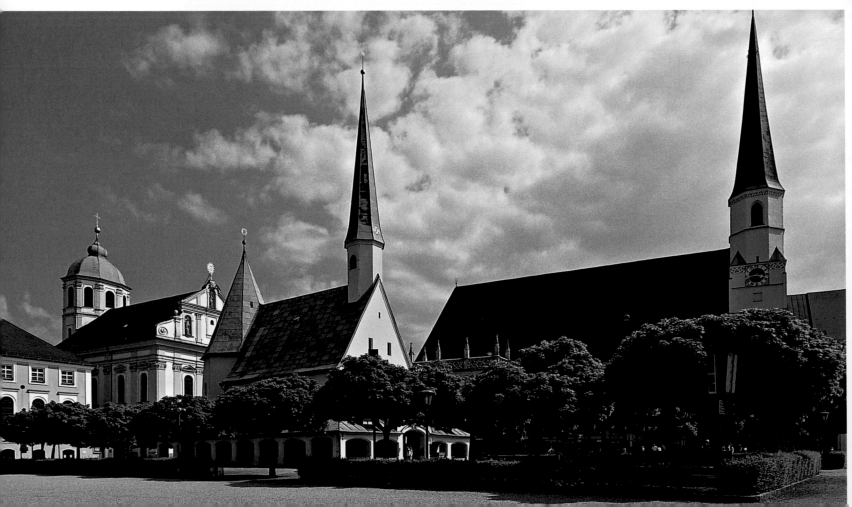

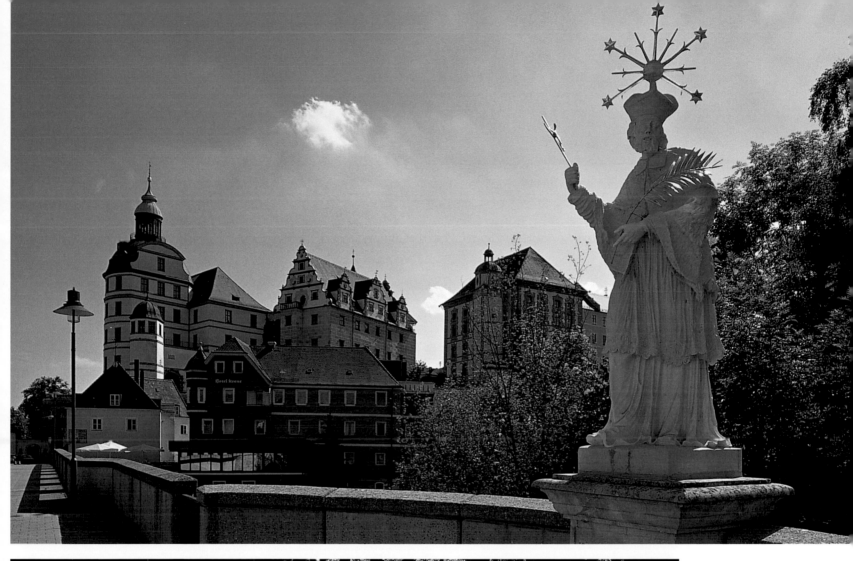

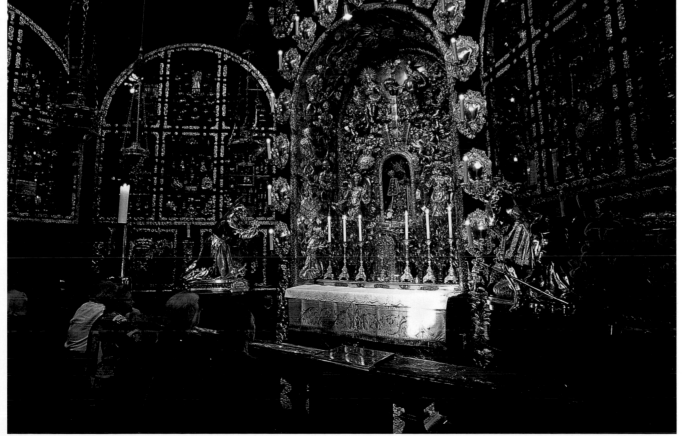

Above:
Neuburg on the River Danube was originally a ducal royal palace and for almost two hundred years the king's residence. The town today and much of the palace are attributed to Count Palatine Ottheinrich whose other major contribution to the secular architecture of Germany is the famous castle in Heidelberg.

Left:
Since 1489 the miraculous statue of the Virgin Mary has drawn countless hoards of pilgrims to the chantry chapel in Altötting. The black madonna, a limewood carving from c. 1300, is encased in a silver tabernacle.

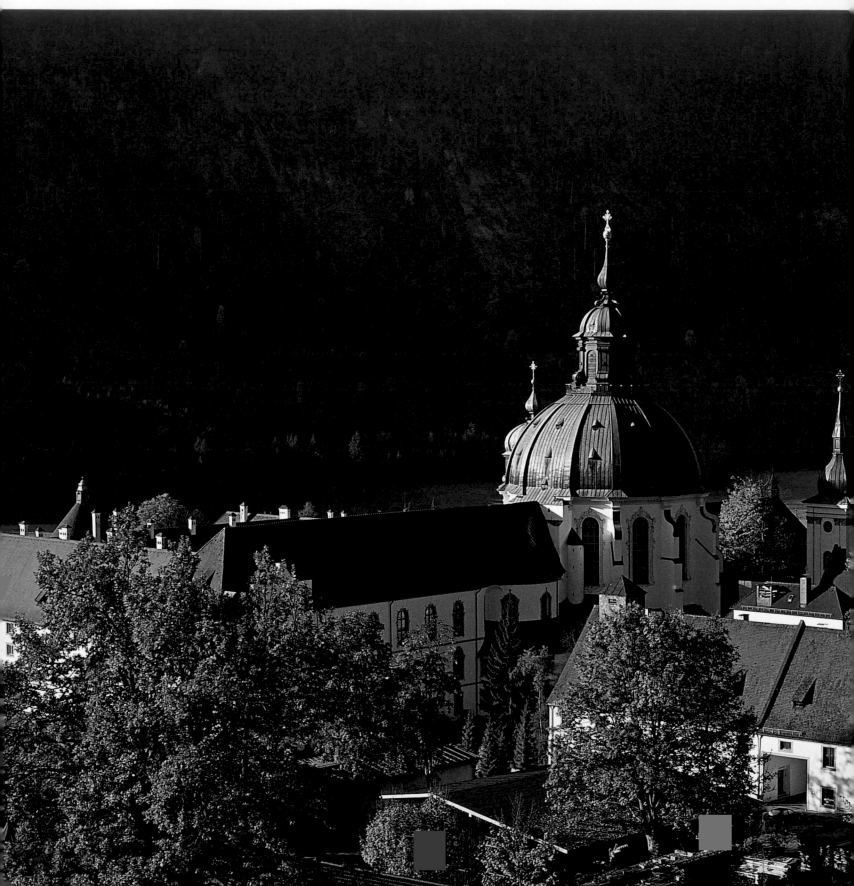

Below:
Ettal Monastery was the result of a vow taken by Emperor Ludwig the Bavarian. Following secularisation the

Benedictines only returned here around 100 years ago. Today the Gothic monastic church gleams in elaborate Rococo.

Top right:
When saints and angels come down from Heaven to Earth no expense is spared. This photo, taken

at a craft fair in Bad Tölz, shows an artist applying gold leaf to one of the heavenly host.

Centre right:
Mittenwald at the foot of the Karwendel Mountains rose to fame and riches thanks to an ancient Roman trade route which passed through its centre.

Italians travelling north introduced the art of violinmaking to Mittenwald and helped cement the economic structure of the town.

Bottom right: *Oberammergau is not only famous for its passion play but also for its traditional carvings. Originally producing religious keepsakes for pilgrims visiting nearby Ettal, the craftsmen soon found their clientele included more worldly customers from further afield. Today the repertoire of wooden figures includes both the sacred and the secular.*

51

Below:

Schloss Linderhof is an elaborate tribute to the artistic pomp of the Rococo. Built here in Graswangtal between 1869 and 1878, the

Rococo experiences a grand renaissance at the hands of Ludwig II, dreamer, architectural fanatic – and king of Bavaria.

Right:

From the giddy 1,761 metres (5,778 feet) of the Herzogstand you gaze out over the Walchensee to the distant icy peaks of the Karwendel. Like his ducal ancestors from the 16th century, King Ludwig II was enchanted by this magical place.

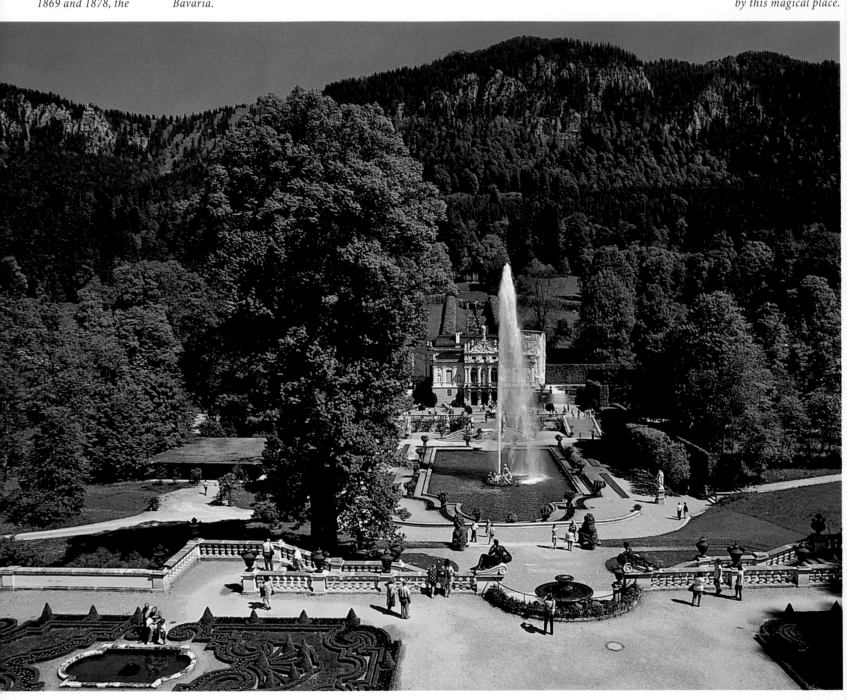

Right:

Benediktbeuern Monastery has a turbulent history going back over 1,260 years. It was re-

built in its present form during the baroque. 1803 saw the discovery of the »Lieder aus Beuern« in the monastic library;

more commonly known as the »Carmina Burana«, the manuscript is a coveted example of medieval goliard poetry.

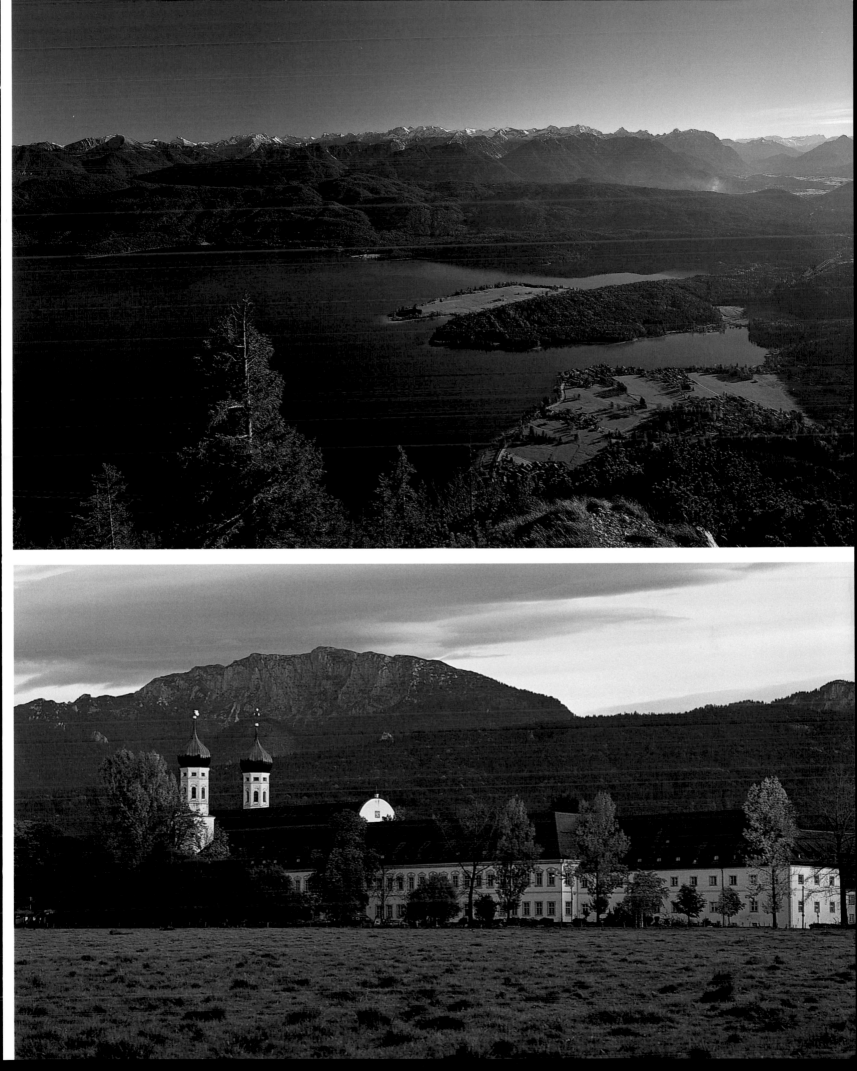

Below:
The Zugspitze bathed
in the evening light.
Germany's highest peak
was climbed for the first
time in 1820 by a team

of 19th-century survey-
ors. Today several rail-
ways lead to the summit,
one of them the ultra-
modern Gletscherbahn
opened in 1992.

Top right:
The romantic Kuhflucht
Waterfalls gush past the
little village of Farchant
with its historic farm-
houses and wonderful
parish church.

Centre right:
View of the Westliche
Karwendelspitze,
2,385 metres (7,825 feet)
above sea level, from the

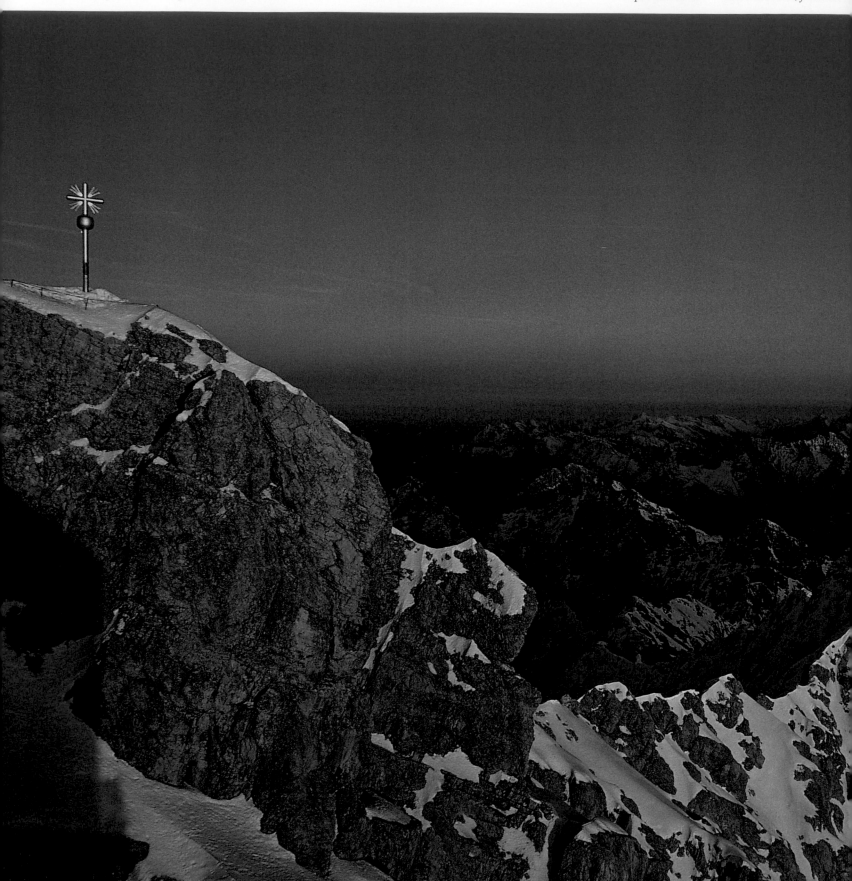

Nördliche Linderspitze. Just below it is the summit station of the cable car which begins its ascent in Mittenwald.

Bottom right:
Just past the Olympic stadium in Garmisch-Partenkirchen the impressive Partnach-klamm carves its way through the mountain- side. Mysterious and almost eerie, in some places the gorge is so narrow that tunnels had to be blasted into the rock face.

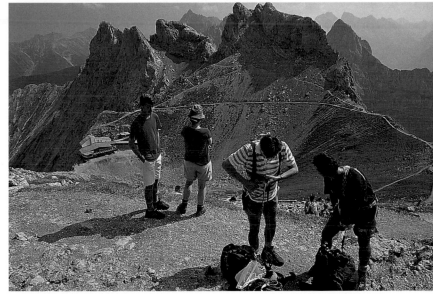

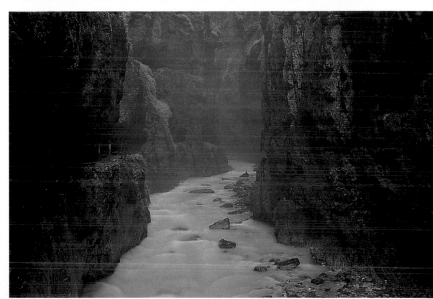

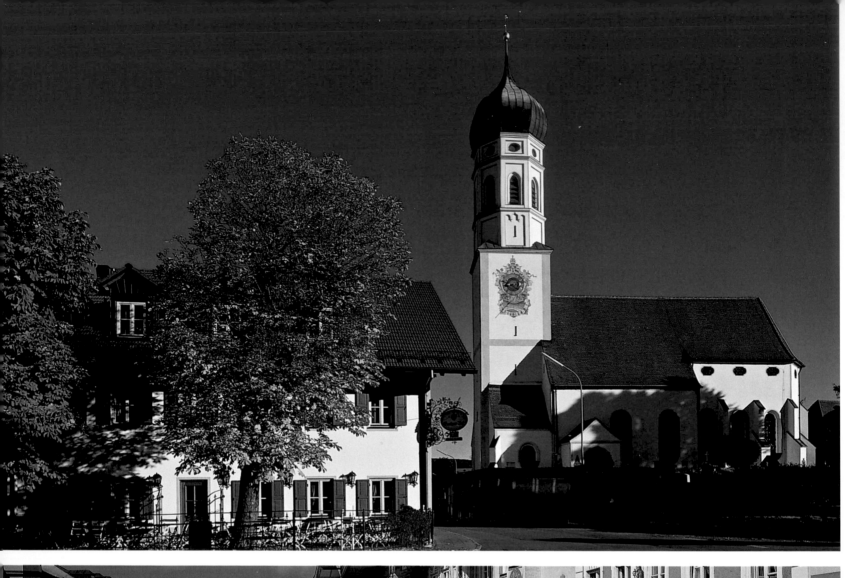

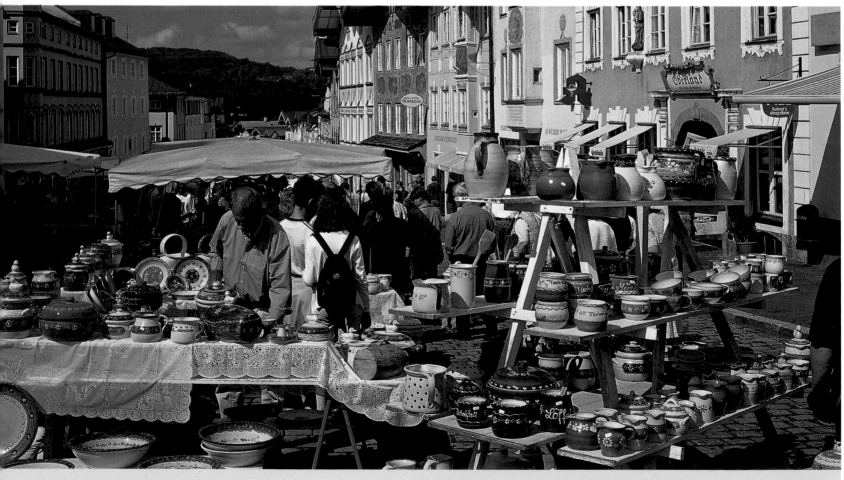

Left:
The idyll of Upper Bavaria wouldn't be complete without an onion-domed church. This house of God in Oberalting in the Starnberg district is dedicated to St Peter and St Paul.

Below left:
Despite appearances to the contrary, the life of the Alpine farmer is anything but idyllic. Not so long ago many were simply struggling to survive.

Below right:
Agricultural tradition and experience are particularly well-heeded in Bavaria. Farmers still stack hay as their forefathers did, for example. Beyond the meadow is the Zugspitze Massif with the Alpspitze and Waxenstein.

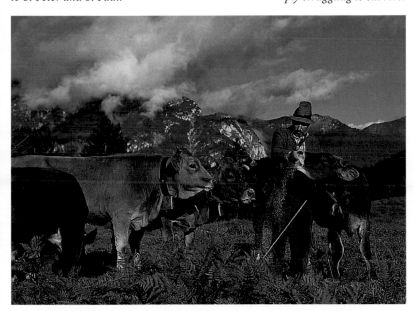

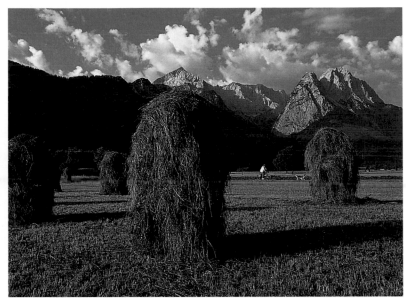

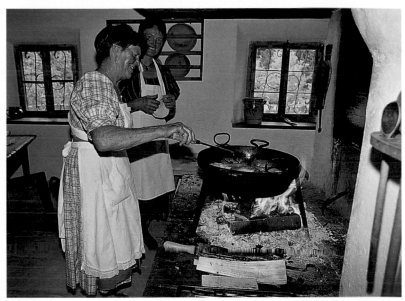

Left:
Pottery market in Bad Tölz. The River Isar splits off the spa quarter from the old town which gradually evolved from a tiny 12th-century fishing settlement. The main thoroughfare of the Altstadt, the Marktstraße, is lined with colourfully sgraffitoed and stuccoed town houses.

Above left:
In 1976 Upper Bavaria's open-air museum on the Glentleiten up above the Kochelsee was opened to the public. The museum features a collection of houses from different regions plus workshops, mills, chapels, beehives, ovens and much more. On special occasions traditional crafts are demonstrated and typical delicacies – here Schmalznudeln – cooked over an open fire.

Above right:
On special feast days the boys of Lenggries abandon their jeans, t-shirts and trainers to sport traditional Lederhosen, felt jackets and knobbly knees.

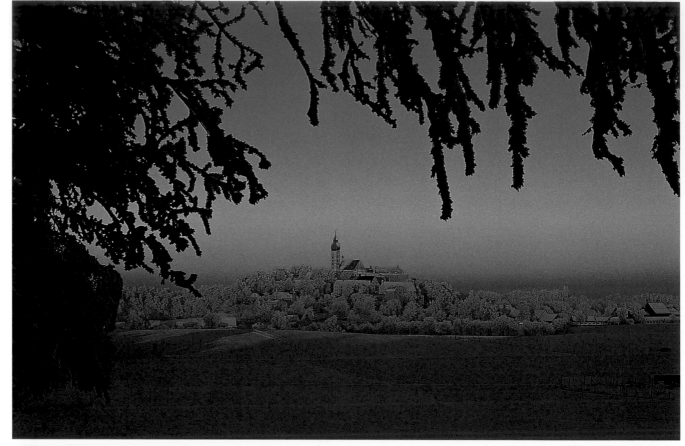

Before it became a 'holy mountain', the rather modest hill on the eastern shores of the Ammersee held a castle. This was replaced by a monastery in the 14th century. What is now Kloster Andechs was originally run by Augustinian canons; in the mid-15th century the complex was taken over by Benedictine monks who turned Andechs into one of the prime pilgrim destinations in Germany.

The famous passion play in Oberammergau takes place every ten years and goes back to a vow taken in 1633 during the Plague. Although the suffering of Christ has been re-enacted indoors since 1900, a lot is still expected from the audience; the theatrical marathon begins at 9.00 in the morning and ends at 5.00 in the afternoon, with just one break for lunch.

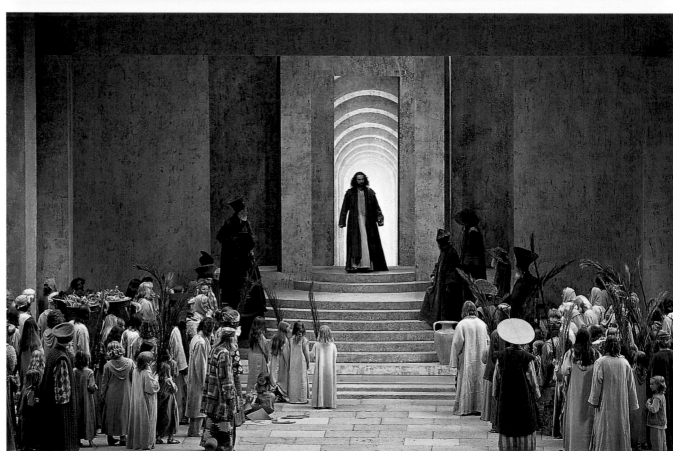

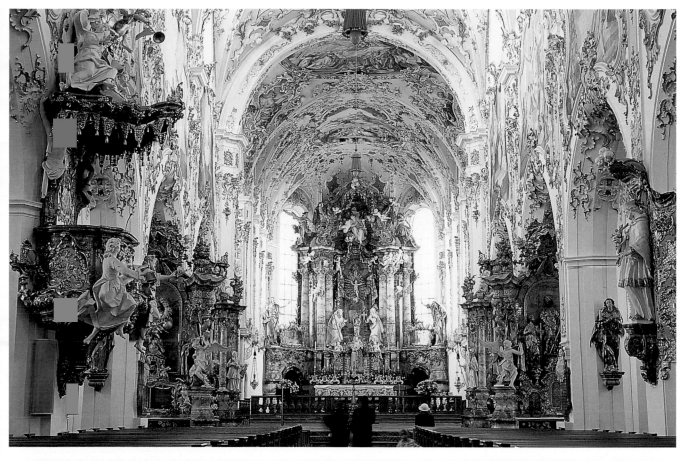

The showpiece of Rottenbuch Monastery in the valley of the River Ammer, begun in the 11th century, is undoubtedly the church of Mariä Geburt. The splendid Rococo interior is the work of father and son Joseph and Franz Xaver Schmuzer.

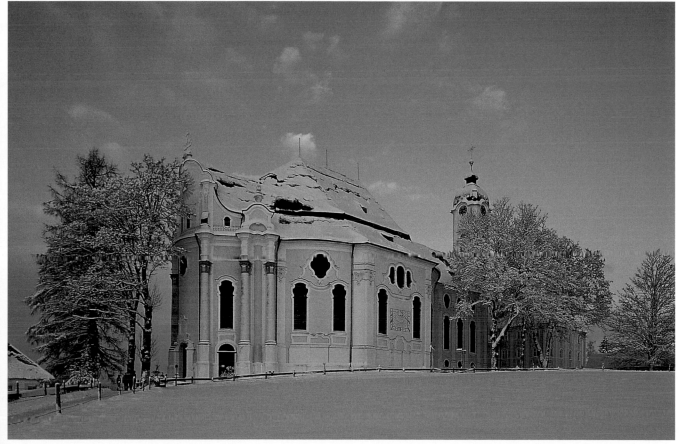

A miracle prompted the construction of the Wieskirche between 1746 and 1754. One day a local sculpture of the suffering Jesus began to shed tears; those who prayed to it found their prayers answered. So many pilgrims flooded to the makeshift shrine that a church was deemed necessary, fashioned in Rococo by the Zimmermann brothers.

Below:
On the southern edge of the Osterseen, a group of around two dozen tiny moorland lakes, is Iffeldorf. The Parish Church

of St Vitus is decorated with ornate Wessobrunn stucco and high-quality ceiling frescoes from c. 1750.

Top right:
Jazz at the Alte Villa in Utting. The spa on the western shores of the Ammersee is popular with health freaks and sailing fanatics alike.

Centre right:
View from the terrace of the Wörthseestüberl out across the lake of the same name with its promise of hours of fun

in the sun. Nowhere else in Bavaria is the water as warm as here, making it ideal for all kinds of sporting activities.

Bottom right:
With a population of ca. 10,000 Tutzing is the second-largest town on Starnberger See. It's also the venue for two major

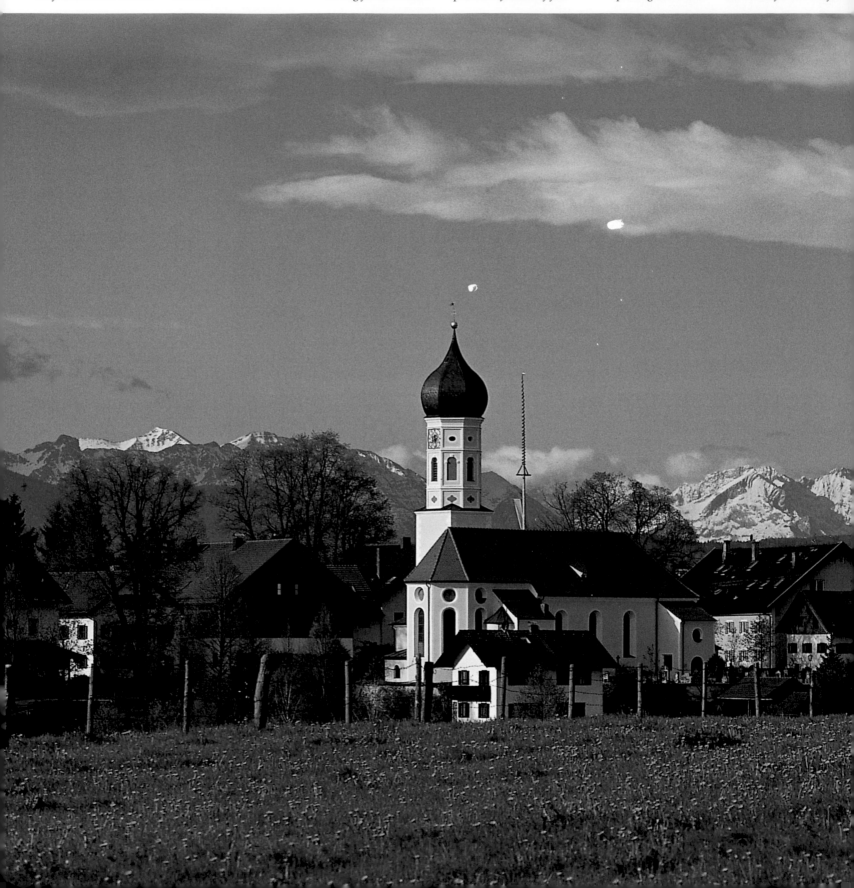

events in the Upper Bavarian calendar; Fischerstechen and the Fischerhochzeit wedding, both of which entail messing about in boats.

Page 62/63: *Possibly the most famous castle in Bavaria, if not in Germany: Schloss Neuschwanstein in its glorious Alpine setting.*

Ludwig II made his own dream come true, modelling his fairytale fortress on medieval originals which included the Wartburg near Eisenach.

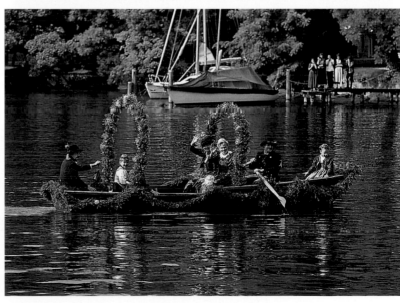

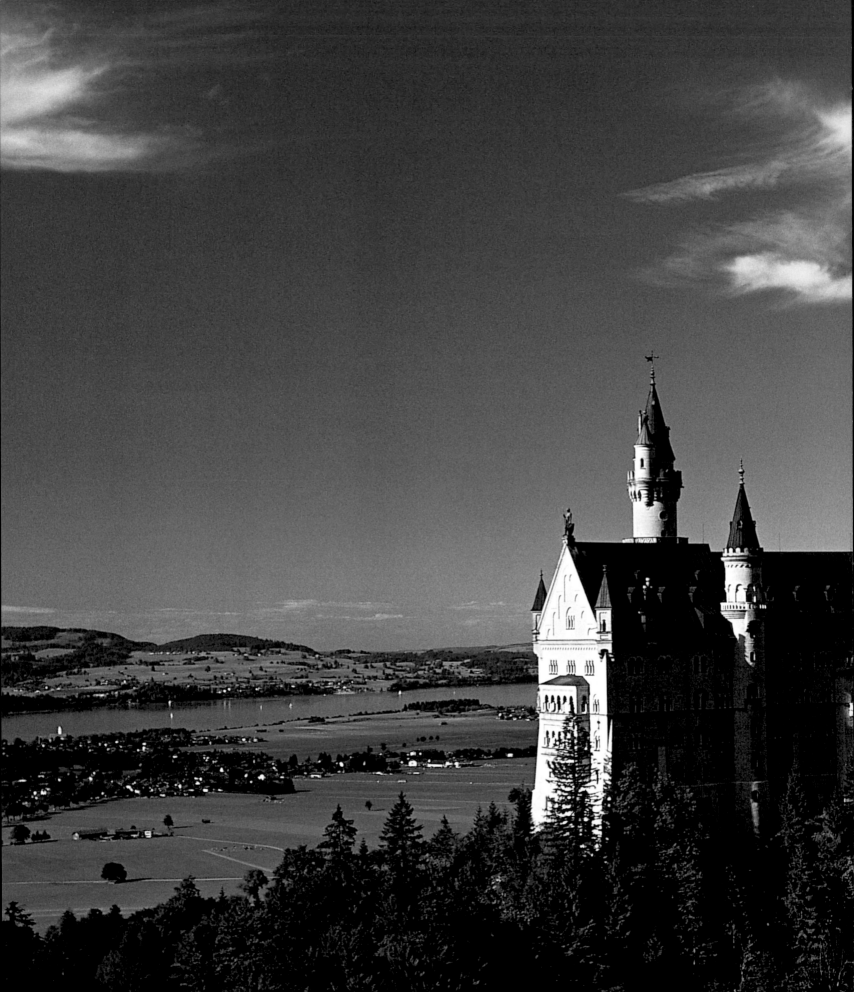

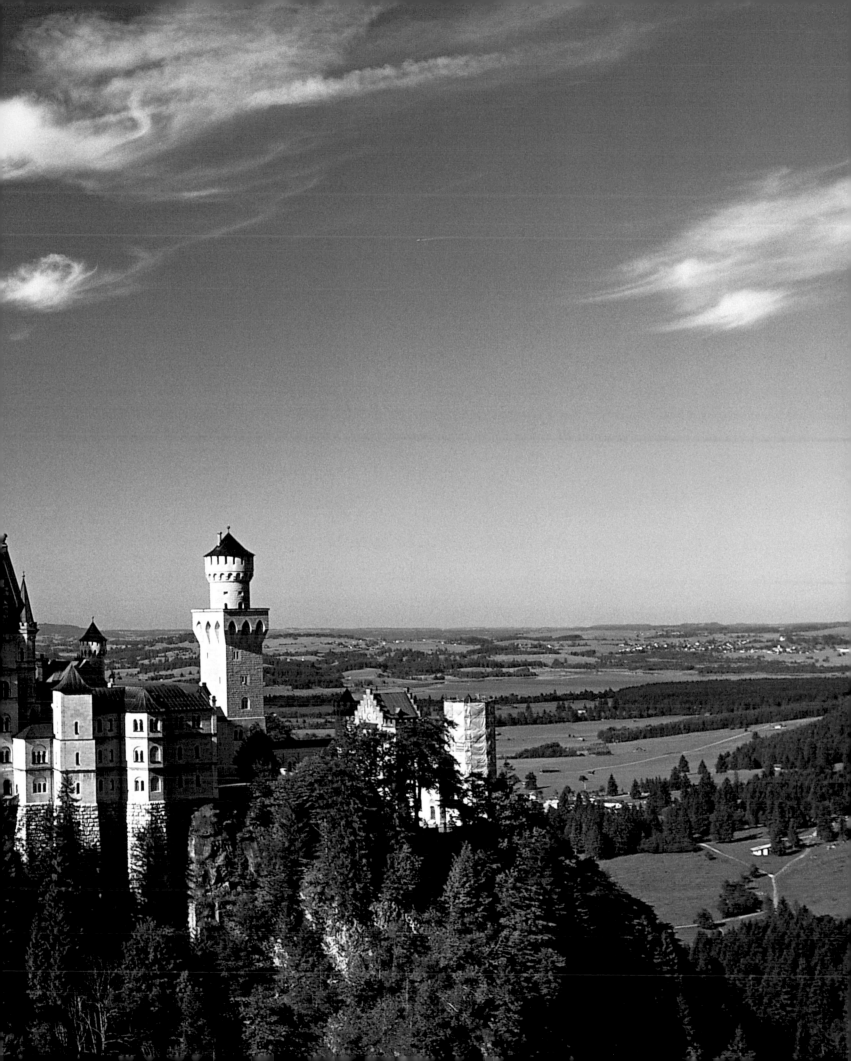

For someone known as The Dream King, it's appropriate that his castles look like something out of a fairy tale. In our prosaic, modern world, Ludwig II and Neuschwanstein, Linderhof and Herrenchiemsee still hold all the magic of a bygone age, drawing millions of tourists each year from all over the globe to Upper Bavaria.

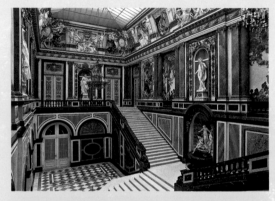

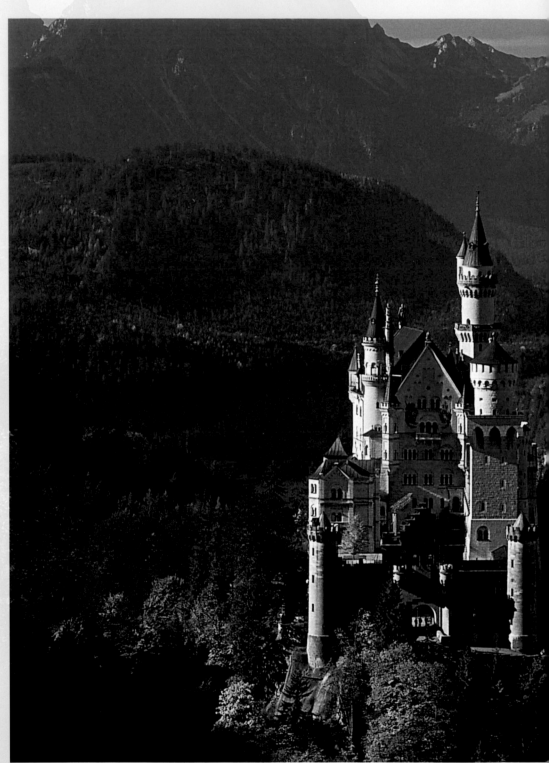

King Ludwig II of Bavaria, son of Crown Prince Maximilian of Bavaria and his Prussian princess wife, was born in 1845. Following the early death of his father, to his absolute disgust Ludwig was made head of government at the tender age of 18. Despite his revulsion, he made an effort to be successful. His endeavours were recognised in 1883, three years before his mysterious death, by none other than the Prussian Imperial Chancellor Bismarck, who conceded that the king ruled »better than all his ministers«. High praise indeed – with an ironic twist. Prussia's hegemonic politics and its two wars were something the sensitive Ludwig absolutely detested. He confided his misgivings to his dear friend Richard Wagner, dreading he would become »a puppet king

Top left:
The Hall of Mirrors, the King's Bedchamber and the incredibly elaborate main staircase are the most popular rooms at Schloss Herrenchiemsee, designed by Julius Hofmann.

Bottom left:
The Oriental Pavilion is one of the many follies scattered about the park at Schloss Linderhof. Initially created for the World Exhibition in

Paris in 1850, the pavilion encapsulates the colour and form of the Arabic world, with the fantastic Peacock Throne as its centrepiece..

Above:
King Ludwig II had Richard Wagner's opera »Lohengrin« in his mind's eye when he had Neuschwanstein erected on the ruins of Vorderschwangau.

AND HIS FAIRYTALE CASTLES

without any power«. Things in fact turned out worse than he feared; at the order of Germany's princes, Ludwig had to offer the imperial crown to his personal adversary, the king of Prussia.

These crass realities would probably have been the end of Ludwig if he hadn't found escape in another, fairy-tale world where he could be king as he saw fit. The Bavarian monarch was a great admirer of the French Sun King Louis XIV. Yet in his desire to honour their shared name he sadly failed to acknowledge that in the one-and-a-half centuries which separated him from the French regent, much had changed. The rest is history. In an attempt to make his wildest dreams come true – that of a poetic existence à la Lohengrin, Tristan and Tannhäuser – he soon found himself in dire financial straits. He grossly underestimated the capacities of the royal coffers, which for a Bavarian king of the bourgeois 19th century were far more modest that those of the absolutist French sovereign. Ludwig's castles swallowed up more funds than he could afford. Accused of bringing the country to ruin, he was deemed an incurable madman and certified. On 13 June 1886, the ill-fated ruler and his psychiatrist were found drowned in the Starnberger See.

THE KING'S BEQUEST

Ludwig's bequest to us are his castles. Ruined Hohenschwangau, for example, was initially only to be turned into a humble baronial abode. The original plans were soon abandoned, however, in favour of designs for a romantic four-storey edifice on a monumental scale. In his mind's eye was a Bavarian version of the palace at the gigantic Wartburg in Eisenach. The king even travelled incognito to Thuringia to see the castle for himself and gain inspiration. Yet time was not on his side. When he died, only part of his dream home of Neuschwanstein was

finished. The rest was completed posthumously in accordance with his wishes and ideas.

In comparison with this fantastic construction set against its bizarre Alpine backdrop, Schloss Linderhof seems extremely unassuming and private. And the park, too, with its contrived Venus Grotto, Moroccan House and Oriental Pavilion, symbolises more a personal preoccupation of the king with foreign myths and cultures rather than something public. Once the monarch had glided through the palace gates in his golden Rococo sledge he was alone, with only his staff to bother him. Linderhof was incidentally the only one of his building projects he saw completed.

His third castle, Schloss Herrenchiemsee on Chiemsee lake, was to be a »new Versailles«. In 1878 the foundations were laid for a huge building whose main façade actually trumped that of the prototype. The king, who usually only came to his island palace at night, attached great importance to detail, insisting that the furnishings be copied from the French originals. While Paul Verlaine celebrated the regent as the »last true king of this century«, others angrily called him a mad squanderer. Ludwig, in his own words, claimed to be neither, professing to »remain an eternal puzzle«.

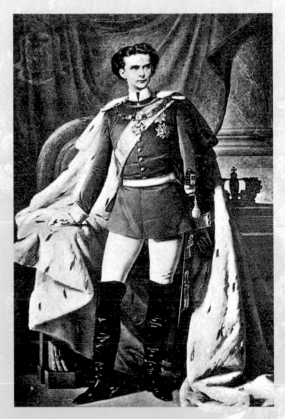

Top right:
The best views of Schloss Neuschwanstein are had from the Marienbrücke, daringly suspended over the steep Pöllatschlucht gorge.

Right:
King Ludwig II, shortly after his ascension to the throne in 1864. His architectural projects proved too adventurous for his advisors, leading to his certification and subsequent deposition in 1886.

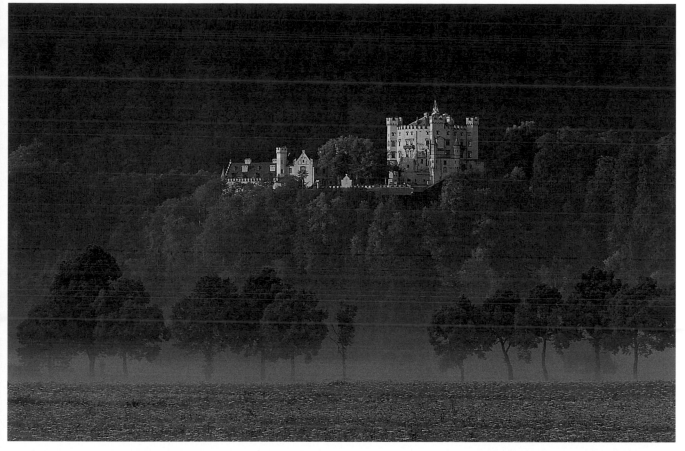

The Schwangau Mountains provide the perfect backdrop for St Koloman, a magnificent chapel of pilgrimage outside the village of Schwangau. Its harmony of line and form again bear witness to the genius of the Wessobrunn School, here Johann Schmuzer.

With the morning mist rising off the meadows, Schloss Hohenschwangau seems to have been catapulted back into the past, where in the days of the Staufer dynasty old Schwanstein Castle was frequented by kings and troubadours.

View across the Forggensee of Schwangau-Waltenhofen and the Tannheim Mountains. The artificial lake, created in 1954 when the River Lech was dammed, is named after the original, much smaller Lake Forggen.

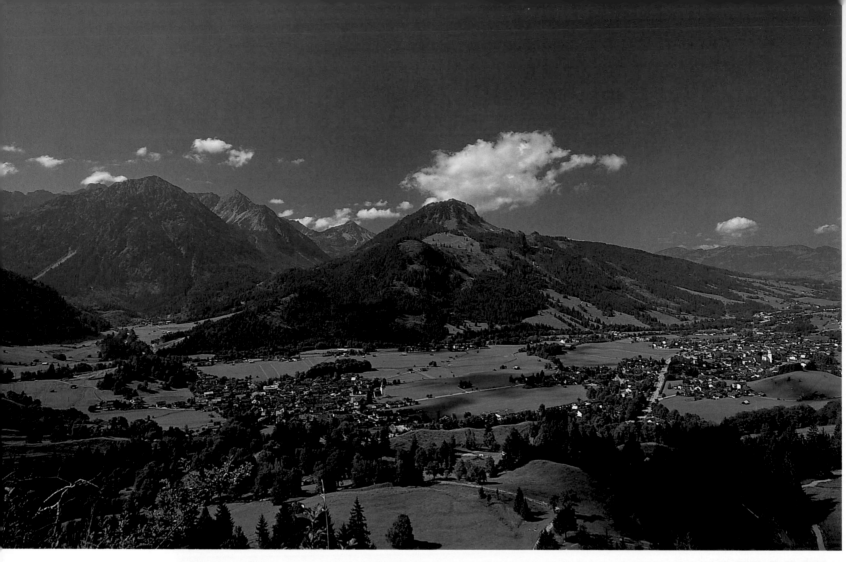

Above:
The Imberger Horn, just 1,656 metres (5,433 feet) high, shelters Bad Oberdorf and Bad Hindelang from the higher elevations beyond it. Approximately four fifths of the local land are nature reserves. Hindelang was one of the initiators of a new model pleading for more eco-friendly tourism in the area.

Right:
Each June the historic Tänzelfest takes place outside the town hall in Kaufbeuren. The town, named after the many merchants' stores (Kaufhäuser) which made it famous in the Middle Ages, was first mentioned at the end of the 11th century.

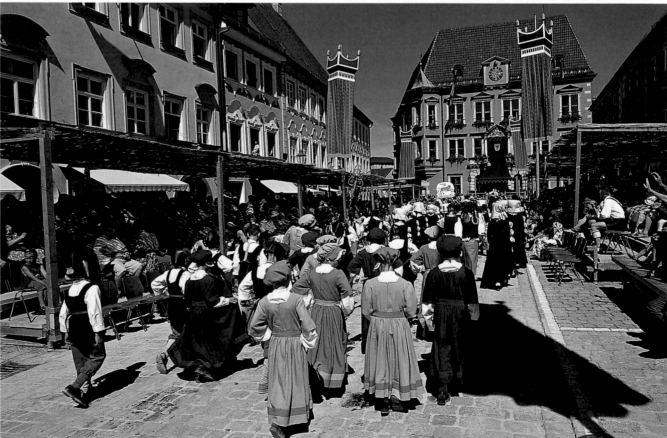

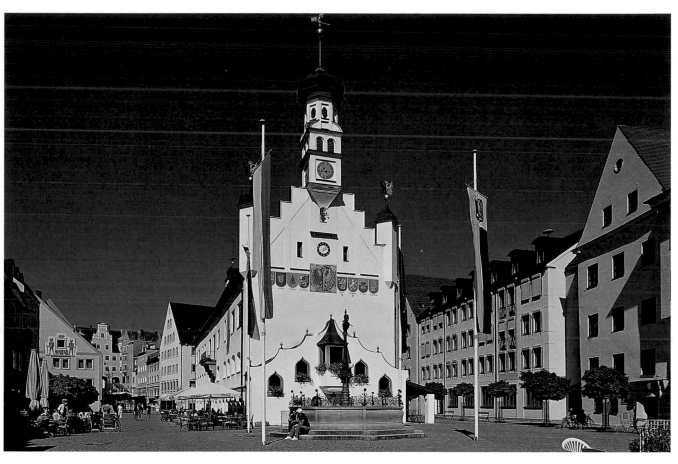

Left:
Kempten, the largest town in the Allgäu, has a rich history which began with the Celts and the Romans and continued with the elevation of the town to a free imperial city, culminating in its use as a royal seat by the local prince-abbot. The town hall from 1474 has managed to retain its basic Gothic makeup despite several spates of restoration.

Below:
Old Füssen lies neat and compact on the opposite bank of the River Lech, here seen from the Kalvarienberg. The Hohes Schloss, formerly the summer residence of Augsburg's prince-bishops, was built on the foundations of a Roman fort.

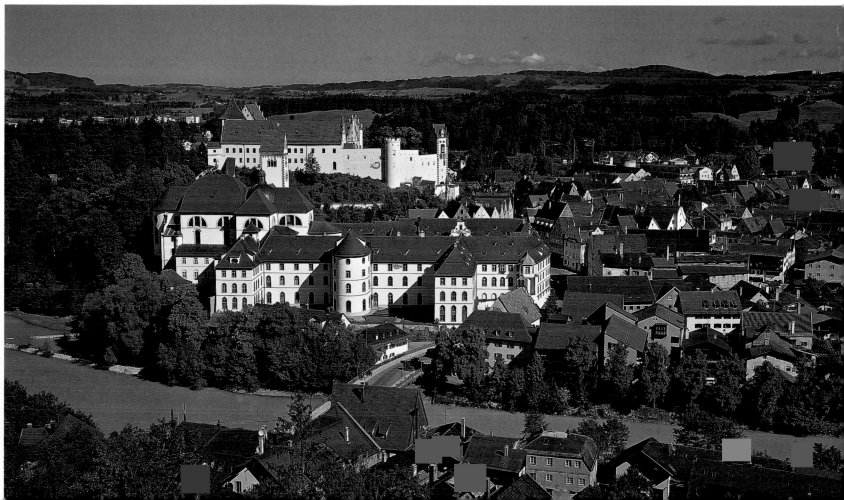

View of Nördlingen from Daniel, as the steeple of St George's is called, one of the largest late Gothic hall churches in Germany. Nördlingen on the Romantische Straße (Romantic Route) was granted its town charter in 1200. The 14th-century walls which enclose the little town are accessible to the public.

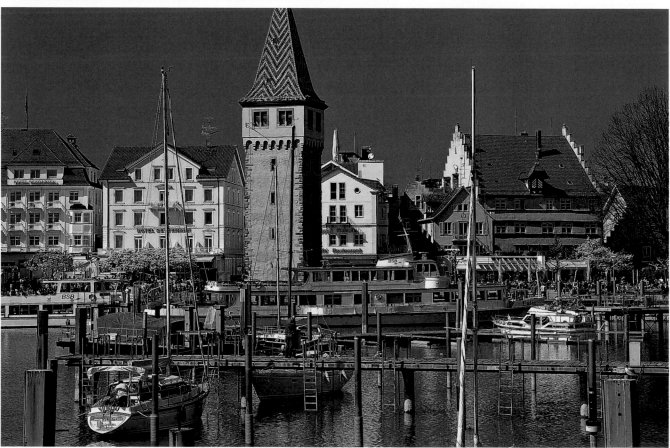

After losing its status as a free imperial city, Lindau on Lake Constance fell to Bavaria in 1805. The picturesque town is a colourful mixture of the medieval, Renaissance and baroque. The old lighthouse in the harbour – Lindau's local landmark – once guided ships safely home after a long day's work.

Augsburg boasts the oldest subsidised housing estate in the world. The Fuggerei has over 50 gabled abodes which accommodate two families apiece. In real terms the rent is as low as it was 500 years ago – just a fraction of the cost for public amenities charged by the council.

Like the armoury and Rotes Tor, Augsburg's town hall and Perlachturm, erected between 1615 and 1620, are the work of Renaissance architect Elias Holl. The town hall's Goldener Saal, an orgy of gold leaf and marble, is well worth visiting.

At the bend in the River Main near Volkach wine is the order of the day. Hardly a patch of earth has been left uncultivated, with vines stretching as far as the eye can see. The grapes are processed in the villages of Escherndorf and Nordheim which hug the curves of the Old Main under sunny skies.

... claims Goethe in his »Götz von Berlichingen«, which is set in this part of Germany. Goethe was personally familiar with much of the area and particularly fond of Nuremberg. Here he bought coins, faïence earthenware and paintings. The only thing he didn't order from Nuremberg was wine; his favourite vintage was Würzburger Stein.

Wine from Franconia is not only popular with the poets. Much of it grows along the shores of the River Main. This, plus the fact that the name of the river and the juice of the grape conveniently rhyme, has made one synonymous with the other; for Mainfranken read »Weinfranken«. Before the river enters the more relaxed climes of Lower Franconia, however, it has to forge its way through the tougher terrain of the Upper Franconian Fichtelgebirge. Beyond this, between the Haßberge and the Steigerwald, the country opens out into rolling vineyards which line the banks of the Main along much of its spectacular course.

Although lacking both Main and wine, connoisseurs reckon the area between Bayreuth, Bamberg and Nuremberg – Franconian Switzerland – to be the best and most magnificent stretch of scenery Franconia has to offer. Nowhere else in Germany is there such an abundance of bizarre rock formations and sheer cliffs, raging rivers and idyllic orchards, precipitous valleys and stony plateaux, dark, ghostly caves and ancient ruined castles. And each of these places, however tiny, has its own particular characteristics – or at least an unmistakable village pub serving unsurpassed local delicacies ...

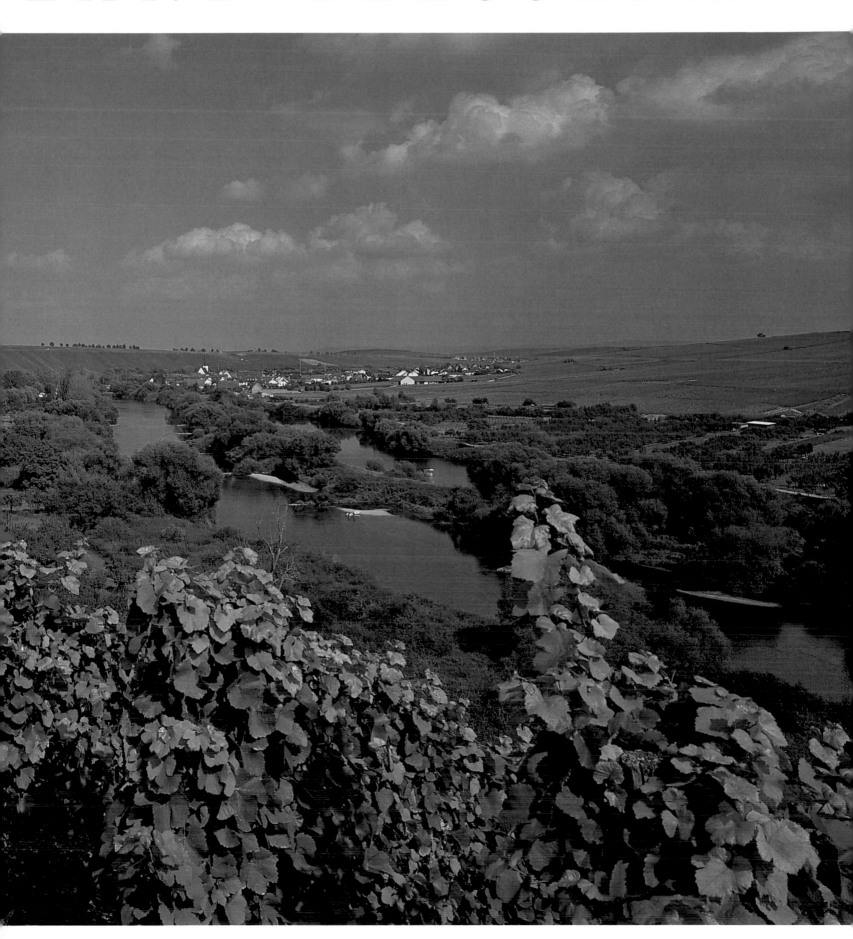

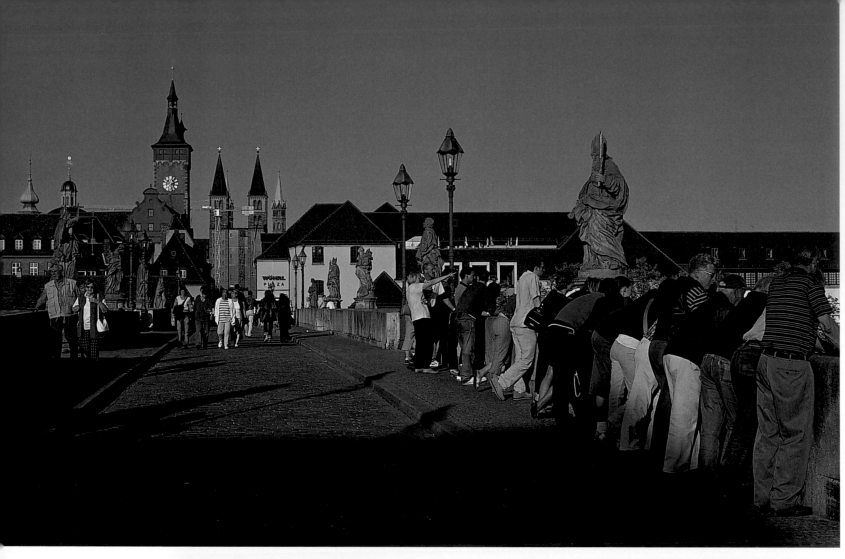

Above:
Würzburg's first bridge
over the Main was erected
in the 12th century. The
current version was built
between 1473 and 1543
and reconstructed after
the Second World War.
The stone edifice is
reserved for pedestrians
only and guarded by
eleven saints and the
Frankish King Pippin,
father of Emperor
Charlemagne.

Right:
After marvelling the
many artistic and
architectural exhibits at
Marienberg Fortress in
Würzburg a bite to eat
under shady trees is an
absolute must.

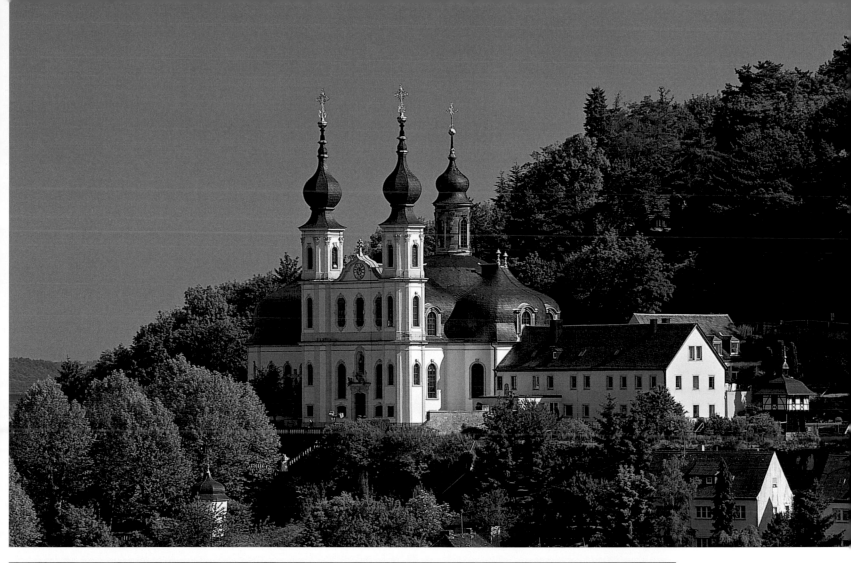

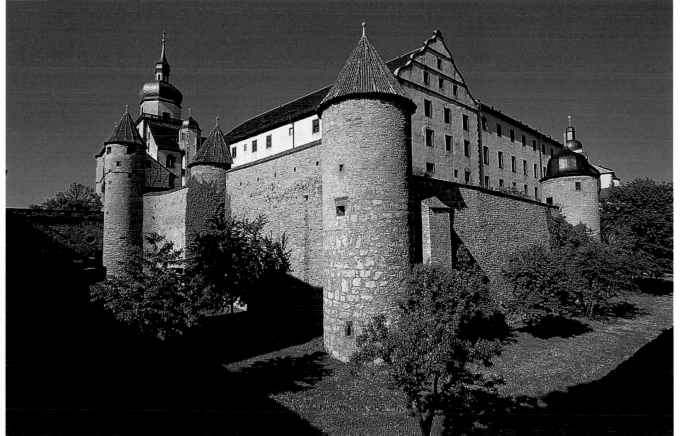

Above:
The Nikolausberg in Würzburg first became a place of pilgrimage during the Thirty Years' War. As its humble chapel was soon unable to cope with the onslaught of visitors, between 1748 and 1752 Balthasar Neumann erected the present church, known as the Käppele or »little chapel«.

Left:
Würzburg's local landmark is Festung Marienberg. Once the centre of episcopal power, it now houses two museums. The highlight of the Mainfränkisches Museum are the many sculptures by Tilman Riemenschneider; the Fürstenbau Museum charts the history of Würzburg and describes the life and times of the prince-bishops.

Below:
The ultimate fairytale castle in Franconia has got to be Mespelbrunn, hidden away in the dark forests of the Spessart. This is where in 1573 Julius Echter was born, who as prince-bishop of Würzburg not only founded a famous hospital but also initiated the bloody and terrible Counter Reformation.

Right:
Schloss Johannisburg in Aschaffenburg, an elegant quadrangle of red sandstone, was built in 1552/1553 by Alsatian architect Georg Ridinger. Once the summer seat of Mainz's electors and archbishops, the building is one of the most magnificent Renaissance palaces in Germany, fully restored following its destruction during the Second World War.

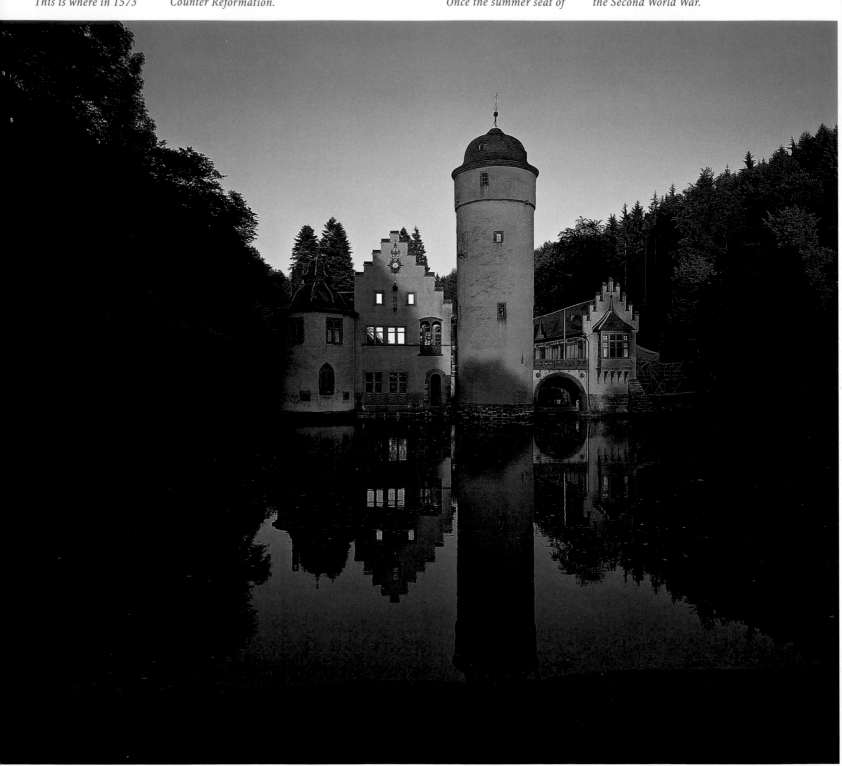

Right:
In Gemünden the rivers Sinn and Fränkische Saale flow into the Main. High up above the old town, which jostles for space with the railway along the narrow river bank, ruined Scherenburg Castle provides a romantic setting for summer theatre productions.

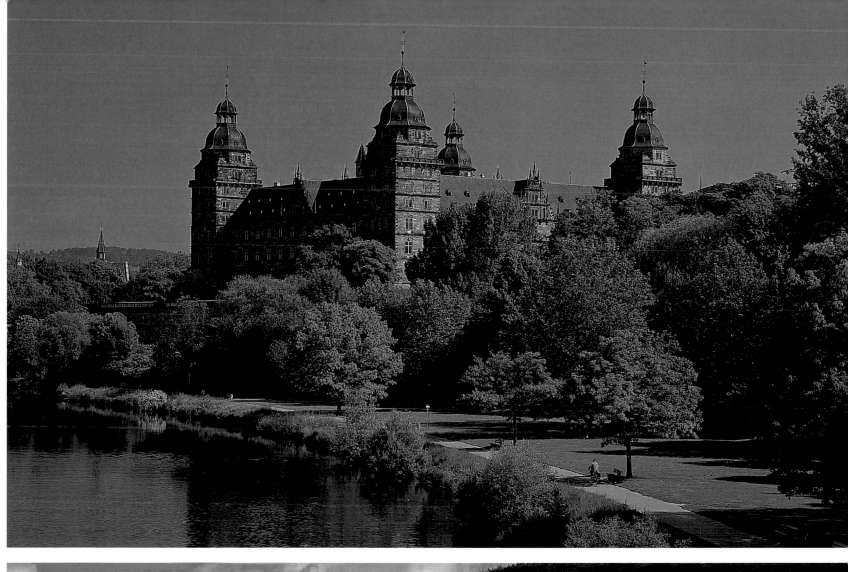

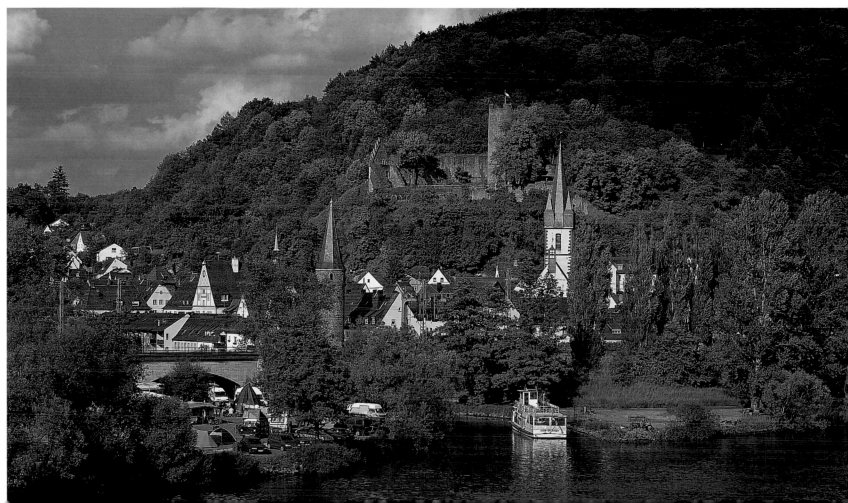

Sommerhausen on the Main is popular with connoisseurs of wine, art and the theatre alike. The many ateliers and galleries welcome both keen aficionados and casual visitors, while the Würzburger Turm boasts the smallest theatre in Germany, founded by Luigi Malipiero and taken over by Veit Relin in 1975.

The fortified town of Dettelbach is just one of the many places which epitomise the romanticism of Mainfranken. Famous for both its wine and its pilgrimage church Maria am Sand, Dettelbach is also popular for its spicy Muskazinen biscuits, originally baked for hungry pilgrims.

Right page:
Ochsenfurt is the German for Oxford, yet here in Lower Franconia the local economy has thrived from its dealings with oxen and not books and students. The town's agricultural past is celebrated at the Ochsenfest each year, when the streets become one huge outdoor wine bar Franconian style.

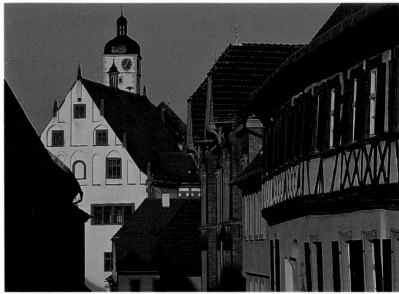

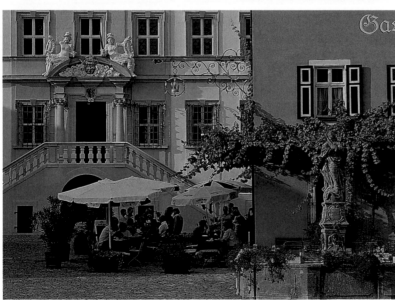

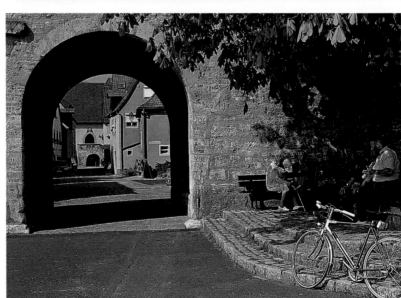

Iphofen is like something out of a picture book; its ancient walls and towers, houses and churches have survived the ravages of time unscathed. The beautiful market place with its magnificent town hall (left), erected by Joseph Greising between 1716 and 1718, is the perfect place to sit and enjoy a glass of the town's reputable wine.

Wine had been a composite part of life in Frickenhausen for over 1,000 years, with the first vineyards recorded as early as in 903. This little town on the banks of the Main, sheltered from the passage of time by its mighty defensive walls, is a feast for both eye and palate, with half-timbered taverns serving local vintages and hearty cuisine.

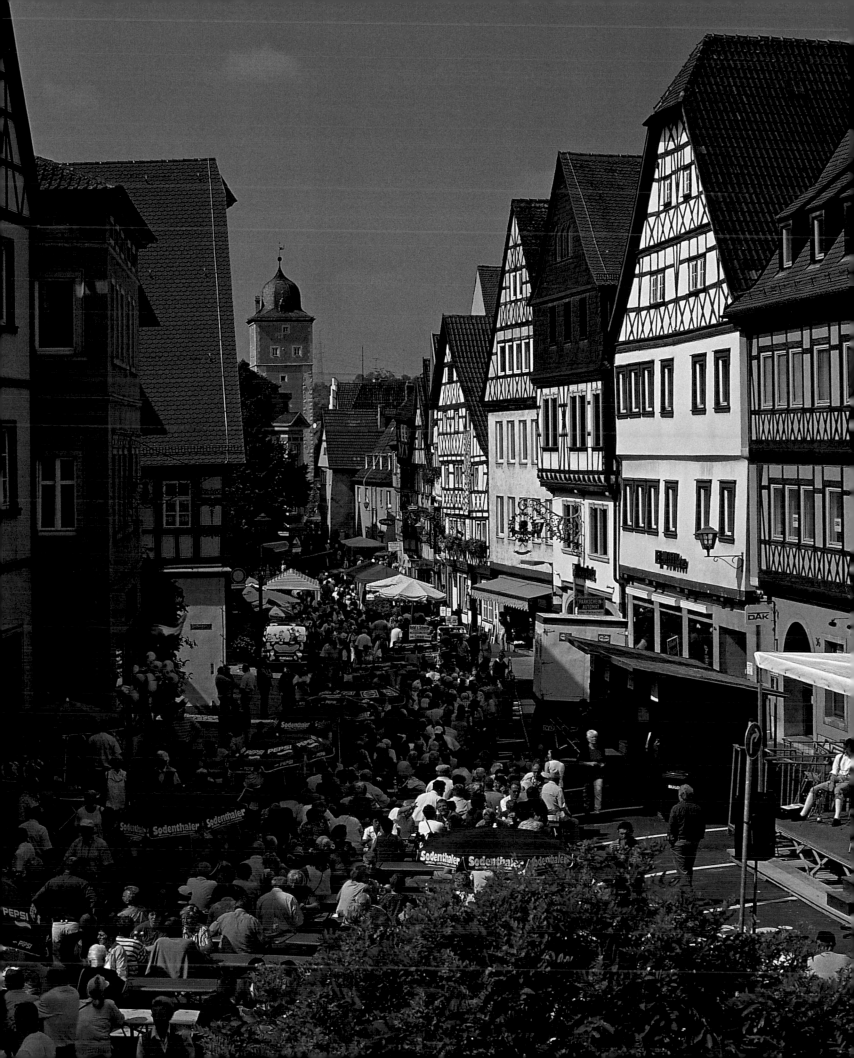

Right:
*Each year at Whitsun
the people of Nesselwang
parade in local costume
to the baroque pilgrim-
age church of Maria
Trost am Berg.*

The dragon is 16 metres (52 feet) long and 3 metres (10 feet) tall. When roused it thrashes its tail, breathes fire and smoke and rents the air with its claws. The dawn of the new often heralds the twilight of the old; here in Furth im Wald daylight brings about a marriage of the two. State-of-the-art mechanics and hydraulics have turned what was

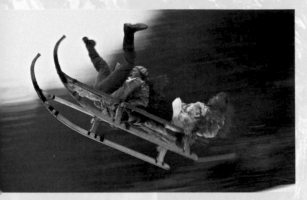

Left:
*Gaißach southeast of
Bad Tölz is the place to
be in January for some
good clean winter fun,
when mad men in silly
costumes race down the
mountainside on two-
seated sleighs, spurred
on by crowds of bemused
spectators.*

once a measly, rather pathetic excuse for a monster into a giant, terrible beast which is speared to death once a year at the Corpus Christi procession held here since the 16th century. The wonders of modern technology make white knight Udo's quest to exterminate this horrific creature more valiant from year to year, attracting more and more spectators to the little town tucked away between the Upper Palatinate and Bavarian forests each August.

The event which allegedly initiated this ancient custom – namely the horrors of the Hussite Wars – has long paled into insignificance; the Landshut Wedding, however, goes back even further. Over 500 years ago, the good burghers of Landshut must have been absolutely flabbergasted by the original nuptials on which today's re-enactment is based: the marriage of the Polish king's daughter Hedwig to George, the son of Ludwig the Rich. Never before had they seen such wealth, such lavish pomp and ceremony. In the autumn of 1475 King Casimir IV arrived at the city gates of Landshut with an entourage of almost 700, plus 100 wagons of royal luggage. The duke of Bavaria for his part made sure nobody left his table hungry. 40,000 chickens, over 1,000 sheep, almost 500 calves, a good 300 oxen and nearly as many pigs were slaughtered for a sumptuous banquet.

Page 81, top:
*Mittenwald, the highest-
lying health and winter
ski resort in the Bavarian
Alps, witnesses a masked
procession each year at
Carnival. With much
banging and shaking of
sticks and rattles the
Schellenrührer drive
away the evil spirits and
cold of winter.*

Page 81, bottom left:
*Driving the cattle down
from the mountainside
in Stoißberg near Anger.
After a long summer
grazing Alpine pastures
the garlanded beasts are
stabled for the winter
months.*

Page 81, bottom right:
*At the traditional
»Drachenstich festival«
in Furth im Wald a fire-
breathing dragon poses a
spectacular (albeit harm-
less) threat to the local
populace. The festival
is based on the legend of
St George.*

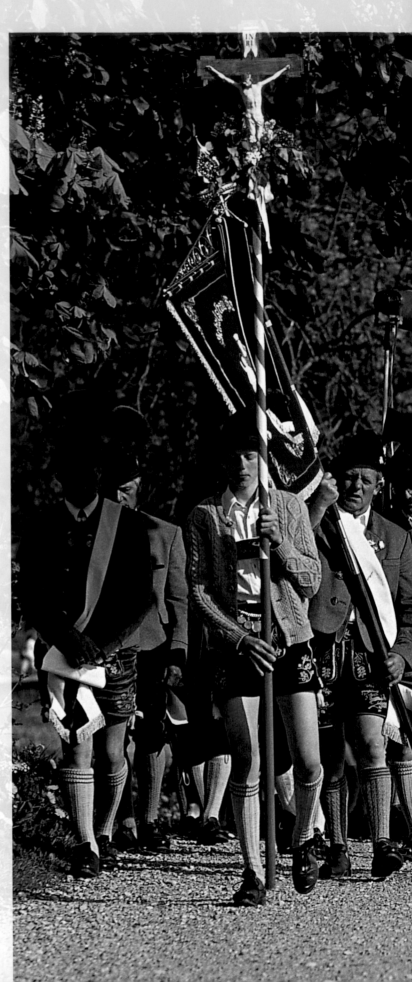

AN INAPPROPRIATE WEDDING

The Agnes Bernauer Festival in Straubing also commemorates a spectacular marriage – or rather, its tragic end. The young bride must have been beautiful beyond all measure. Why otherwise would the ducal heir, Albrecht II of Bavaria, have ignored all the rules of royal protocol to secretly marry the daughter of a lowly barber – a profession of ill repute to boot? Albrecht's father felt forced to bend several laws to rectify the situation; he had his despised daughter-in-law tried for witchcraft and drowned in the River Danube. Albrecht, who had been enticed away from the royal household on a bogus mission, was forced to condone the deeds of the state but was undoubtedly plagued by a bad conscience forevermore. After having

ach can be equally fortified at other well-known Bavarian places of pilgrimage, such as Weltenburg and Vierzehnheiligen. Altötting, which houses Bavaria's oldest shrine devoted to the Virgin Mary, became the number one pilgrim destination in the whole of Germany without the added attraction of an alcoholic beverage – a grand testimony to the ongoing appeal of this wonderful and sacred place.

In no other federal state in Germany does the festive calendar contain so many events based on tradition and ancient custom. The year kicks off in spring with processions through the meadows and an entire catalogue of rituals for Easter and continues with the erecting of the maypole, ancient Whitsun parades on horseback and feast days held in honour of church patrons and various saints. In Mainfranken hardly a

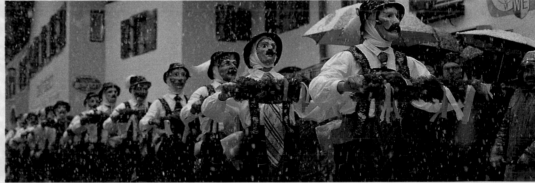

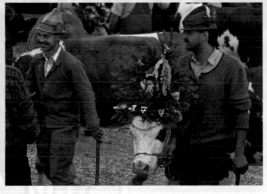

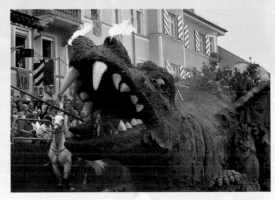

established a Benedictine monastery at the ancient pilgrim site of Andechs, he stipulated that he be buried in its church and – according to contemporary reports – had the mortal remains of his unfortunate Agnes laid to rest there. Pilgrims flock to the priory today not to contemplate this sorry tale but to admire the monastery's famous relics and sample its equally famous brew – not necessarily in that order. Then as now the old saying holds true: Andechs lives from prayer and beer alone. Both soul and stom-

weekend goes by in late summer and early autumn without a festival dedicated to Bacchus, the god of wine. It's thus hardly surprising that Bavaria is also the venue for Germany's oldest, biggest and best-known Christmas fair: Nuremberg's Christkindls-markt.

At 500 hectares (1,235 acres) of vineyard, Nordheim is the most productive wine-growing community in Franconia. Practically every second building is a winery. Many of the village's top wines are matured in the cellars of W Braun (shown here).

One of the main events in the vinaceous year is the wine harvest. This is when the vintner makes his first prognosis as to the quantity and quality of the year's vintage.

Right:
The aptly named pilgrimage church of Maria im Weingarten houses one of the masterpieces of German woodcarving in Tilman Riemenschneider's Madonna im Rosenkranz.

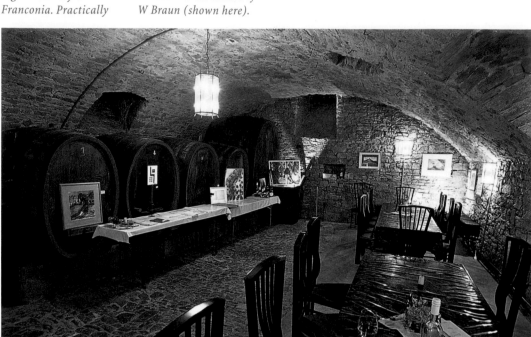

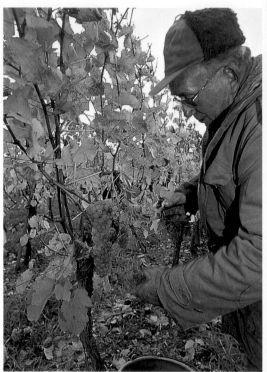

Although the present version is just a copy, the late Gothic wayside shrine outside the gates of Sommerach is no less impressive. Originally fashioned in 1511, the sculpture is very finely worked with an unusual array of figures.

Where better to try some of the local wines than at this tavern in Volkach on the Main? The garden at Gasthaus Behring is wonderful on a summer's evening, with candle-lit vines and fairy lights creating an aura of romantic Gemütlichkeit.

Right:
Prichsenstadt is Rothenburg ob der Tauber in miniature. Its Renaissance and baroque buildings, protected by sturdy walls and towers, have been excellently preserved.

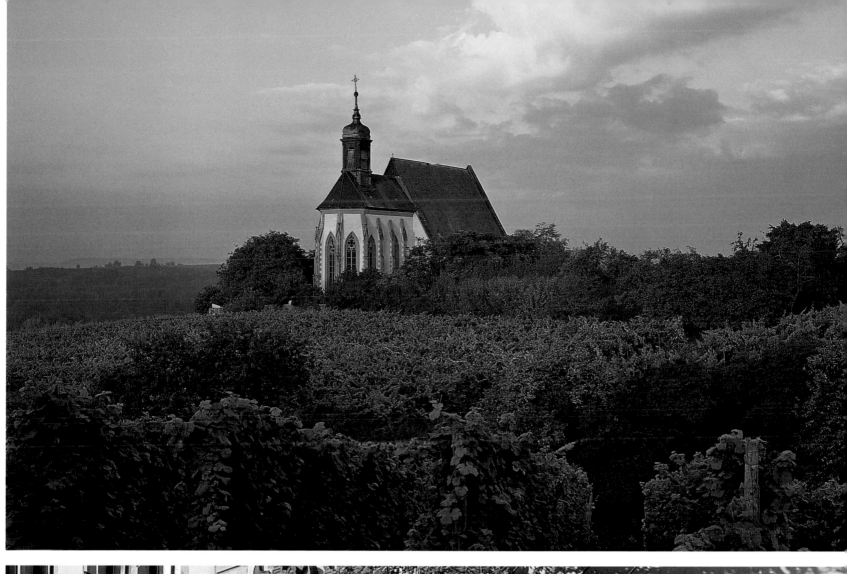

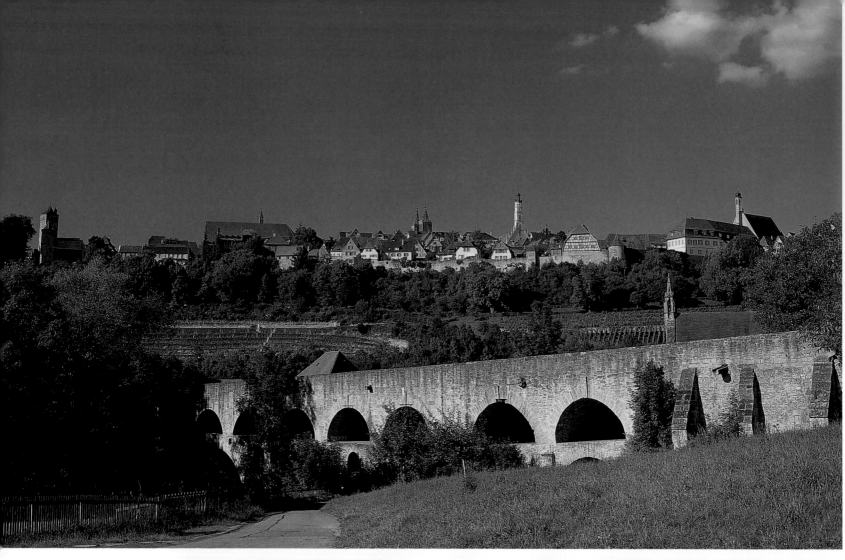

Above:
Rothenburg ob der Tauber is the epitome of the medieval German city, complete with all the historic trimmings. Miraculously, the »only« parts which fell victim to the bombings of the Second World War were the town hall, a section of the town wall and a few private houses. The twin bridge in the foreground spanning the River Tauber was erected in 1330.

Right:
One of Tilman Riemenschneider's chief works of art can be found in Rothenburg's parish church of St Jakob. The central section of the Altar of the Holy Blood, carved between 1501 and 1504, depicts the Last Supper.

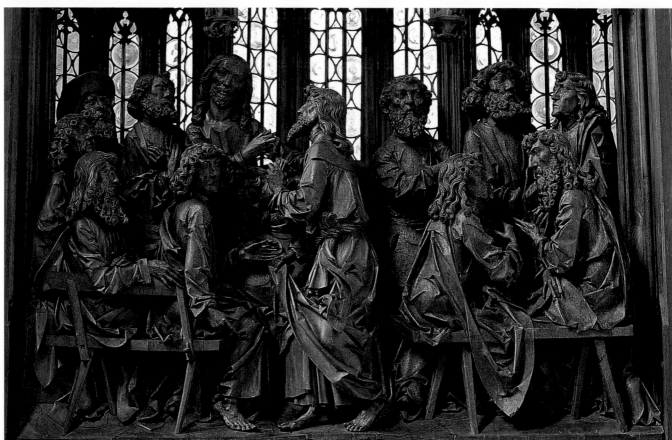

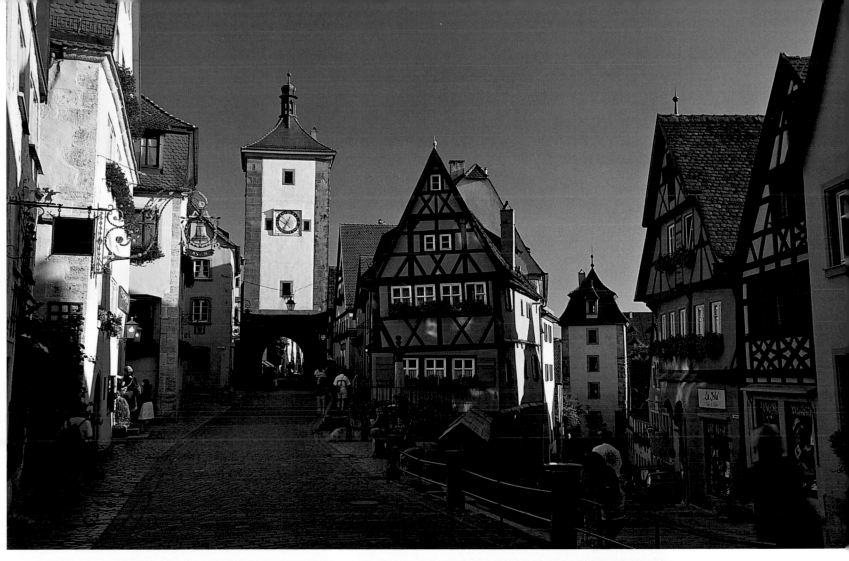

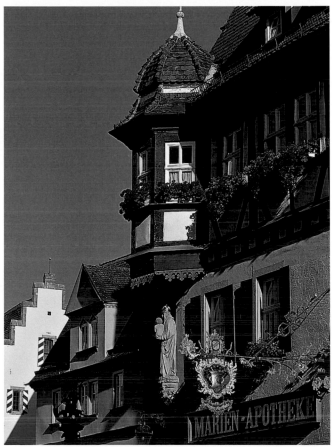

Above:
Perhaps the most pictur-
esque spot in Rothenburg
– one of the many – is
Plönlein, where narrow
cobbled streets fork off
towards two of the city's
gates.

Far left:
Defensive walls, squat
towers and impenetrable
bastions guard all
entrances to Rothen-
burg's historic centre.
The Kobolzeller Bastei
(shown here) monitors
all visitors approaching
from the Tauber Valley.

Left:
Rothenburg's market
place has witnessed
many a historic event
over the course of the
years, such as the
triumphant entry of
Commander Tilly during
the Thirty Years' War.

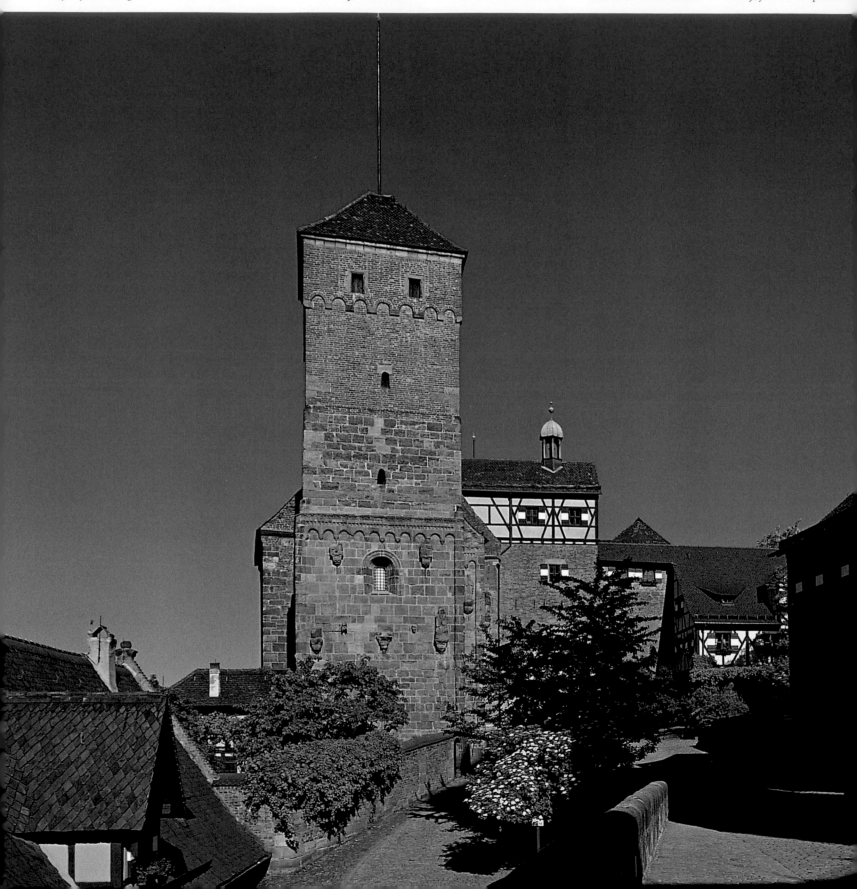

Below:
Nuremberg, the largest city in Franconia, is dwarfed by its castle which contains not one but three independent sets of defences origi-nally manned by the emperor, the town and the castle counts. The most significant archi-tectural feature still intact is the Romanesque double chapel where both the emperor and his court could worship – on sepa-rate levels, as befitting their respective ranks.

Top right:
Nuremberg's Christ-kindlesmarkt with the Frauenkirche in the background. Each year the Christ Child ceremo-niously opens Germany's oldest and best-known Christmas fair from the ramparts of the church, built on the foundations of an ancient synagogue. Specialities of the fair include Rauschgoldengel and Pflaumenmännlein, traditional decorations.

Centre right:
Nuremberg is famous the world over for its ginger-bread or Lebkuchen. Originally baked only within the monastery walls, the sweetmeats of honey, flour and special

spices were soon sold to the worldly community without, with Emperor Frederick III even inviting local children to a grand gingerbread feast at the castle in 1487.

Bottom right: *Nuremberg's Handwerkerhof, its permanent craft market, was opened in 1971, the year of Dürer's anniversary.*

Although it contains more shops than artisans' workshops, visitors find it hard to pass by without buying a souvenir or two.

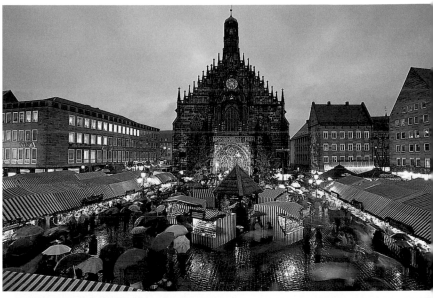

Right:
Feuchtwangen looks back on a thousand years of history. Art historian George Dehio went into raptures about its wonderful market place, claiming it to be the »ballroom of Bavaria«.

Below:
The old part of Erlangen is a homage to the geometric symmetry of the baroque. Destroyed by fire in 1706, it was rebuilt in the style of the Huguenot settlement erected by Margrave Christian Ernst von Brandenburg-Bayreuth in 1686 just south of Erlangen. The settlement housed ca. 600 Huguenots who had fled France to avoid religious persecution.

Above:
Late medieval Dinkels-
bühl grew up around
a Carolingian royal
court. The abundance
of houses dating back
over 400 years elegantly
denotes its great histori-
cal importance: here,
Segringer Straße and the
buildings once inhabited
by wealthy town dwellers.

Left:
The rapids of the Pegnitz
River not only brought
trade to the town of Lauf
(»course of a river«) but
also possibly gave it its
name. The many water
and hammer mills along
its banks were legendary.

Left page:

Ansbach, now the administrative capital of Middle Franconia, was ruled for almost 500 years by the house of Zollern (later Hohenzollern). Until 1976 their mortal remains were laid to rest in the late Gothic Johanniskirche on Oberer Markt, built between 1435 and 1508.

After visiting the margraves' castle, the orangery and the palace gardens in Ansbach, a mug of beer under the shady trees of the An der Riviera pub is more than welcome...

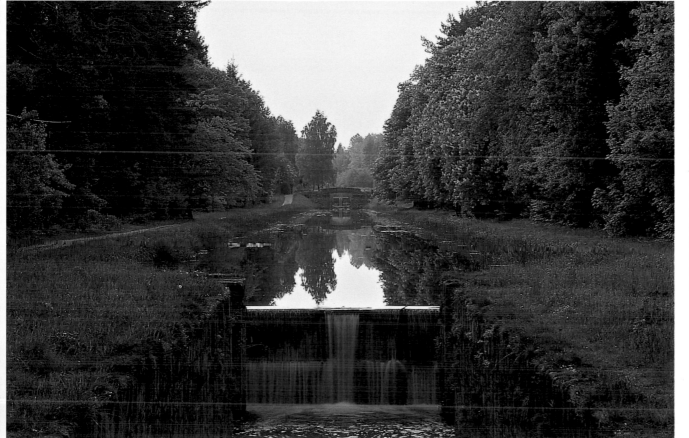

The first monarch to attempt to link the Main and Danube rivers was Emperor Charlemagne. It wasn't until the reign of King Ludwig I of Bavaria much, much later, however, that Charlemagne's idea was successfully put into practice. On 15 July 1846 178 kilometres (110 miles) of canal were ceremoniously opened. This 19th-century waterway has since been replaced although parts of it still exist, such as here near Schwarzenbruck.

Above:

Bayreuth is inextricably linked with the life and work of Richard Wagner. The Festspielhaus, built between 1872 and 1876 on a hill on the edge of town, was opened to the gusty strains of »The Ring of the Nibelung«.

Right:

Thanks to Margravine Wilhelmine the park of the Eremitage laid out on a bend in the River Main became a focal point of life at court. The Neues Schloss was erected between 1749 and 1753 by royal architects Joseph Saint-Pierre and Karl Philipp von Gontard, its half-moon arcades sheltering a monumental fountain.

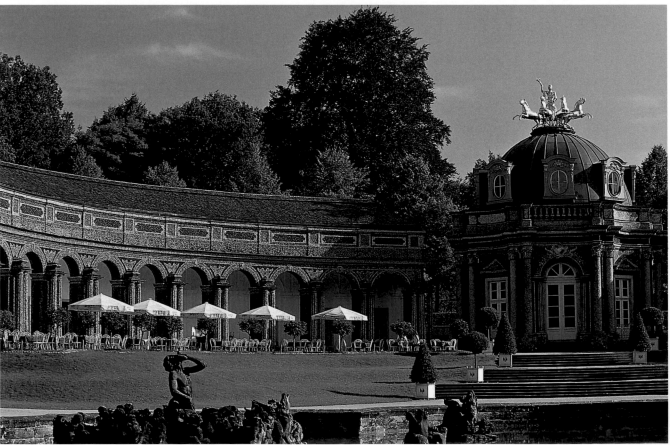

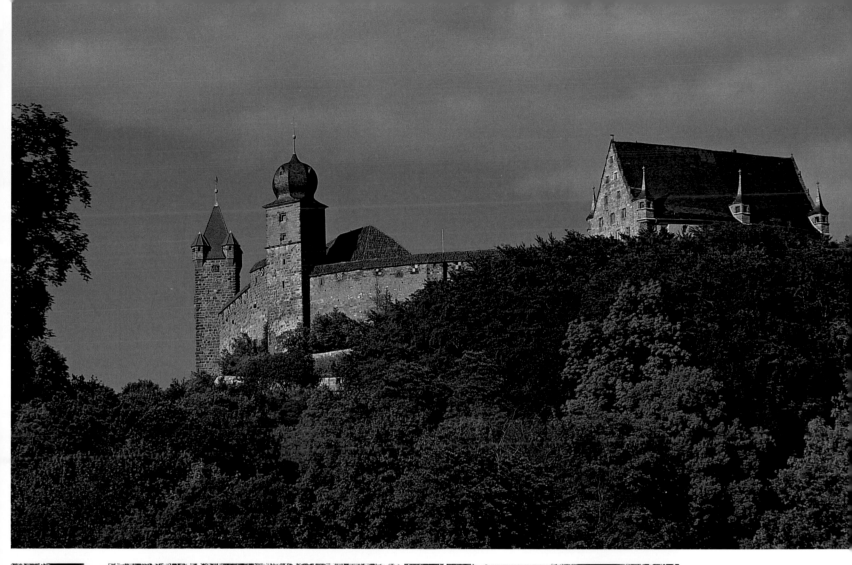

Above:
The fortress at Coburg is one of the biggest and best medieval castles in Bavaria. In 1530, during the Imperial Diet of Augsburg, Martin Luther found sanctuary here for a few months.

Left:
Schloss Weißenstein in the village of Pommersfelden near Bamberg was completed in just five years. It was built by Lothar Franz von Schönborn, then prince-bishop of Bamberg and elector-archbishop of Mainz, one of the richest and most influential men of his day. The magnificent, opulent palace is surrounded by glorious parkland.

93

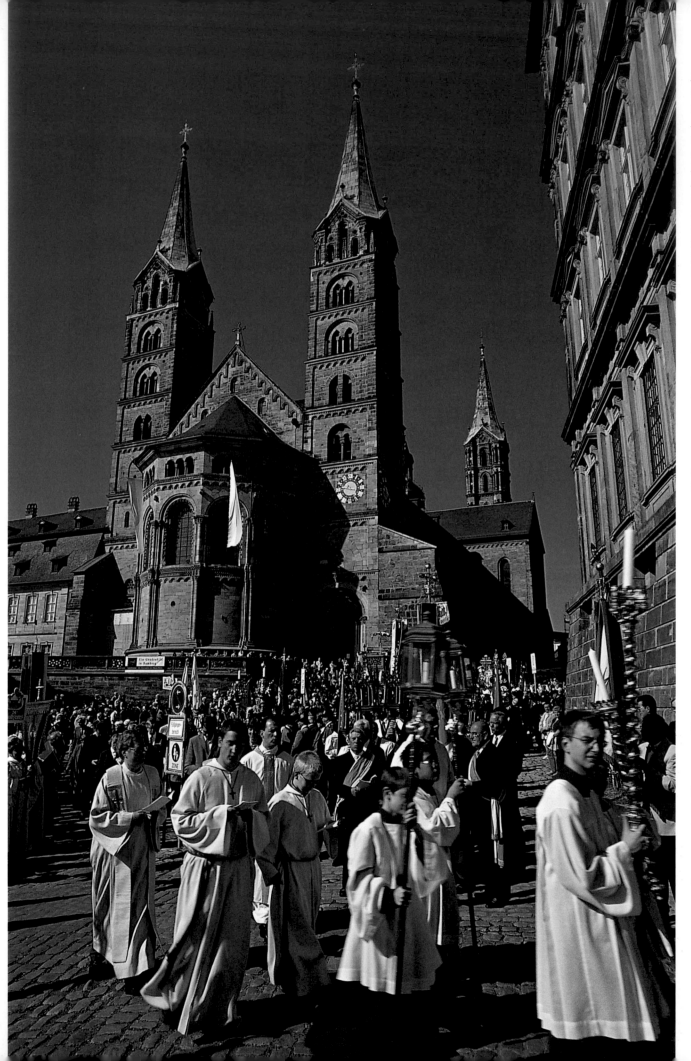

Left:
Corpus Christi parade on the cathedral square in Bamberg. Built on the ruins of two older places of worship, the present Romanesque and Gothic structure was consecrated in 1237. Of its many works of art, the Bamberg Rider, »the perfect ideal of high medieval kingship and knighthood«, is the most famous.

Right:
Boatsmen and fishermen used to live in this vivid array of houses lining the Regnitz River in Bamberg. The best views of Little Venice are to be had from the Markusbrücke, the Untere Brücke just outside the town hall and the opposite bank known as Am Leinritt after the men on horseback who used to haul the boats upstream by rope.

Right:
Bamberg's main square is enclosed by the cathedral and the city's old and new palaces. The Neue Residenz was constructed by master architect to Prince-Bishop Lothar Franz von Schönborn, Johann Leonhard Dientzenhofer. The showpiece of the palace is undoubtedly the Kaisersaal or imperial ballroom; there are also works of art to marvel at in the Bayerische Staatsgemäldesammlung and valuable books and manuscripts to read in the state library, both within the palace building.

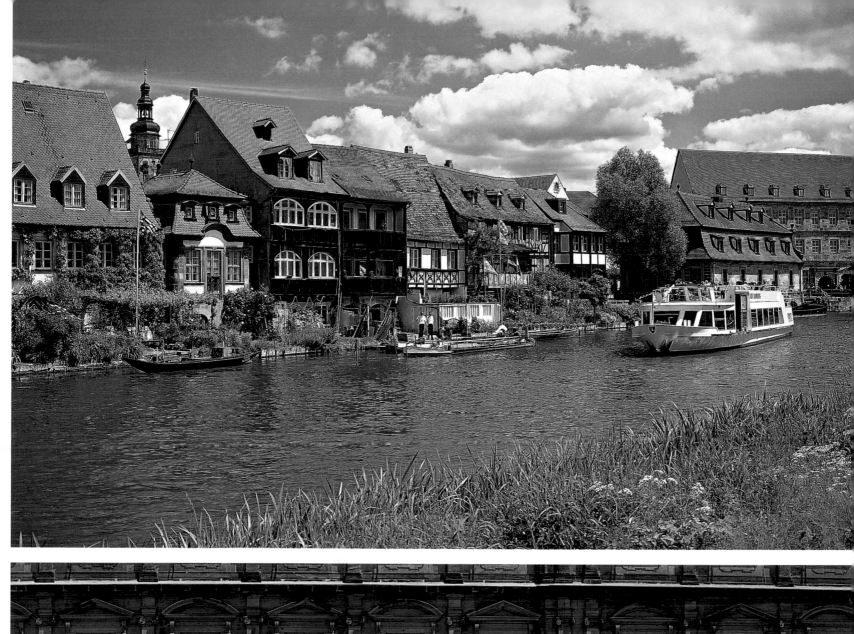
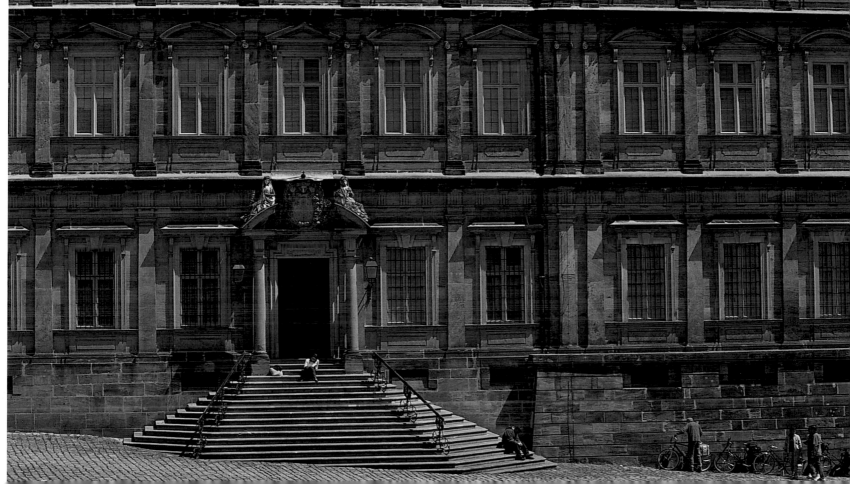

BAVARIA'S »LIQUID

»I drank seven or eight litres – almost a litre of pure alcohol – and was totally inebriated", reminisces American writer Thomas Wolfe about his trip to Munich's Oktoberfest in 1928. He also remembers that he then got involved in a fight which gave him concussion, four wounds to the head and a broken nose. Both the underestimation of the potent festival brew and the overestimation of your own strength after having consumed it are the commonest side effects of a visit to the largest and most famous funfair in the world, which draws millions to the Theresienwiese from all over the world each autumn.

It all began on 17 October 1810 with some simple horseracing, staged in honour of the wedding of the crown prince, later King Ludwig I, and Theresa of Saxe-Hildburghausen. Unlike the marriage the festival was a big hit, with new attractions added year after year. 1811 saw the introduction of an agricultural show, with horses and cattle – or rather their owners – vying for honorary titles and prize money. The first swings appeared in 1818 and just two years later merry-go-rounds joined the merry throng – together with various side shows, circus artistes and exotic exhibits. Here you could come to marvel at the genuine (or alleged) wonders of the world: five-legged calves and two-tailed oxen, ladies without a lower half, hairy lion-men and Siamese twins, performing fleas, singing sea lions and dancing minstrels. Much water has flowed along the Isar since then and today's attractions are very different; stomach-churning roller coasters

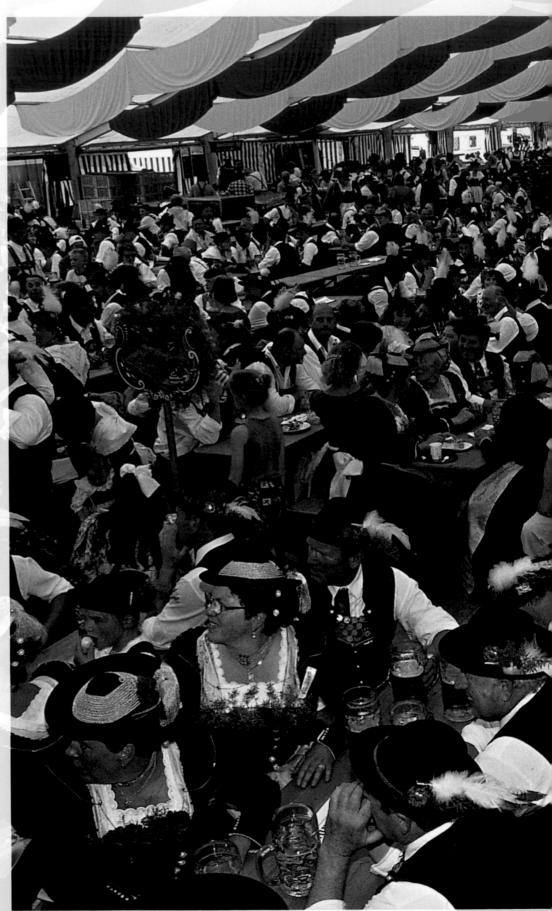

NOURISHMENT« – BEER

Left:
A festival just isn't a festival in Upper Bavaria without beer – preferably plenty of it, here being supped by a merry throng at the Loisachgau festival in Egling-Neufahrn.

Far left:
The old brewing room at the Schlossbrauerei zu Au (in the Hallertau) is now a unique pub serving the local brew.

Below:
A (beer) garden within a (park) garden. Relaxing in the sun – over a beer – in Munich's Hofgarten.

and other high-tech rides which make you feel dizzy just to look at them have stolen the show. The Oktoberfest is the place where the newest inventions in the field are sampled first; each year heralds the arrival of some new record-breaking phenomenon.

It goes without saying that visitors who subject themselves to such energetic exertions need to refuel on a regular basis. Horrendous amounts of sausage, fried chicken, fish, veal knuckle and all kinds of roast meat are consumed, victuals both hot and cold, sweet and sour – all washed down with several litres of that infamous Oktoberfest beer. The countless food outlets are rather modestly referred to as beer tents, but in reality these are huge, comfortable marquees, portable pubs with all the trimmings. The Guinness or rather Oktoberfest Book of Records wouldn't be complete without a few entries from the waitresses; these stalwart

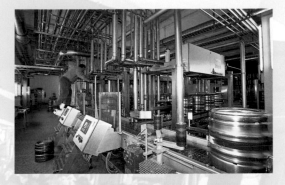

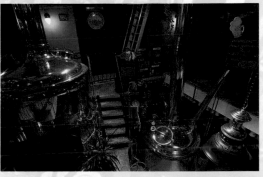

Right:
The Benedictine monastery of Weihenstephan in Freising was granted the right to brew beer in 1146; one of its hop fields even dates back to 768 (top).

Gleaming vats – such as these here at the Schloderer Bräu in Amberg – are a sign of sterling work and painstaking production (centre).

Harvesting hops in Hörgertshausen. Almost one quarter of the world's hops is cultivated here in the Hallertau region (bottom).

lasses stride from table to table for hours on end, brandishing 10 heavy litre mugs of beer on each trip. Luckily a plea from the German Teetotallers Association in 1910 went unheeded; it called for a ban on women waitresses at the festival for reasons of moral etiquette.

THE LARGEST NETWORK OF BREWERIES IN GERMANY

Even if they wish they had, the Bavarians did not invent beer. They have, however, succeeded in making it part and parcel of their very existence and their regional culture – probably for ever. The German Purity Law, which stipulates that beer may only contain barley malt, hops and water and is still in effect today, goes back to two of Bavaria's dukes and will celebrate its 500th anniversary in 2016. Yet laws alone are not enough; a good beer requires both careful processing and quality raw materials. The Bavarians leave nothing to chance in this respect (»only the best ingredients for the best beer«), cultivating top-quality hops in the Hallertau hills between Ingolstadt and Munich. The latter would like to claim to be the beer capital of the world. The Bavarian metropolis is, however, facing some stiff competition in Upper Franconia; the area between Bamberg, Bayreuth and Kulmbach boasts the largest and tightest-knit network of breweries in Germany. However, what goes in must come out. Even satirist Jean Paul could not defy the laws of nature. When after one particularly indulgent pub crawl in Bayreuth he was caught relieving himself against the wall of a house, he paid for his beer twice; firstly for its consumption and secondly for its unseemly disposal.

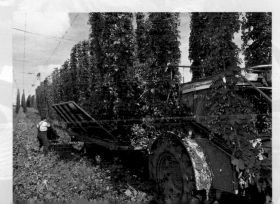

Below:
The Basilica of the Holy Trinity in Gößweinstein is just one of the architectural masterpieces Balthasar Neumann has bequeathed to Franconia.

Gößweinstein Castle in the background allegedly provided Wagner with a model for his Castle of the Holy Grail in Parsifal.

Top right:
Tüchersfeld is the perfect embodiment of the romanticism of Franconian Switzerland. The little village snuggles up to the jagged dolomite precipices which overhang it. Two castles once guarded the passage through the valley.

Centre right:
With its sheer drop down to the River Main, the Staffelberg was the ideal place to establish a Celtic oppidum. Far below it in the water

meadows lies the little town of Staffelstein where in 1492 mathematical genius Adam Riese first saw the light of day.

Bottom right: In 1985 the Judenhof at the foot of Tüchersfeld's twin towers of rock was turned into a museum devoted to Franconian Switzerland. The buildings (erected 1758–1762) replaced the lower defences of the town's castle and housed the Jewish community until 1872.

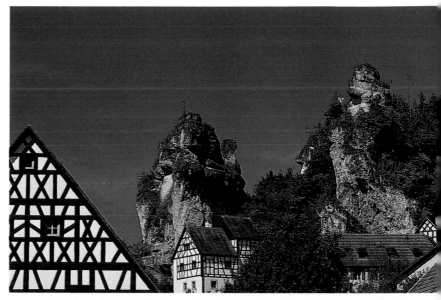

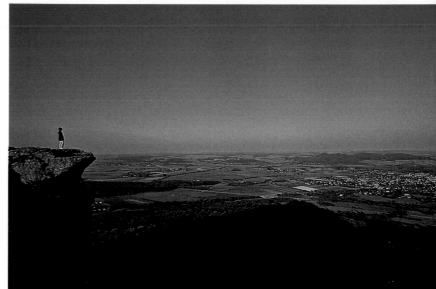

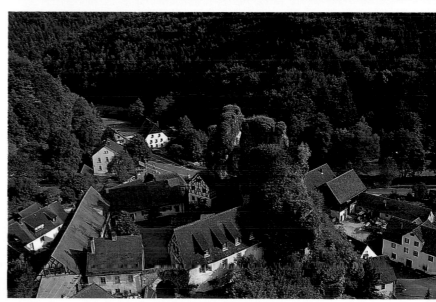

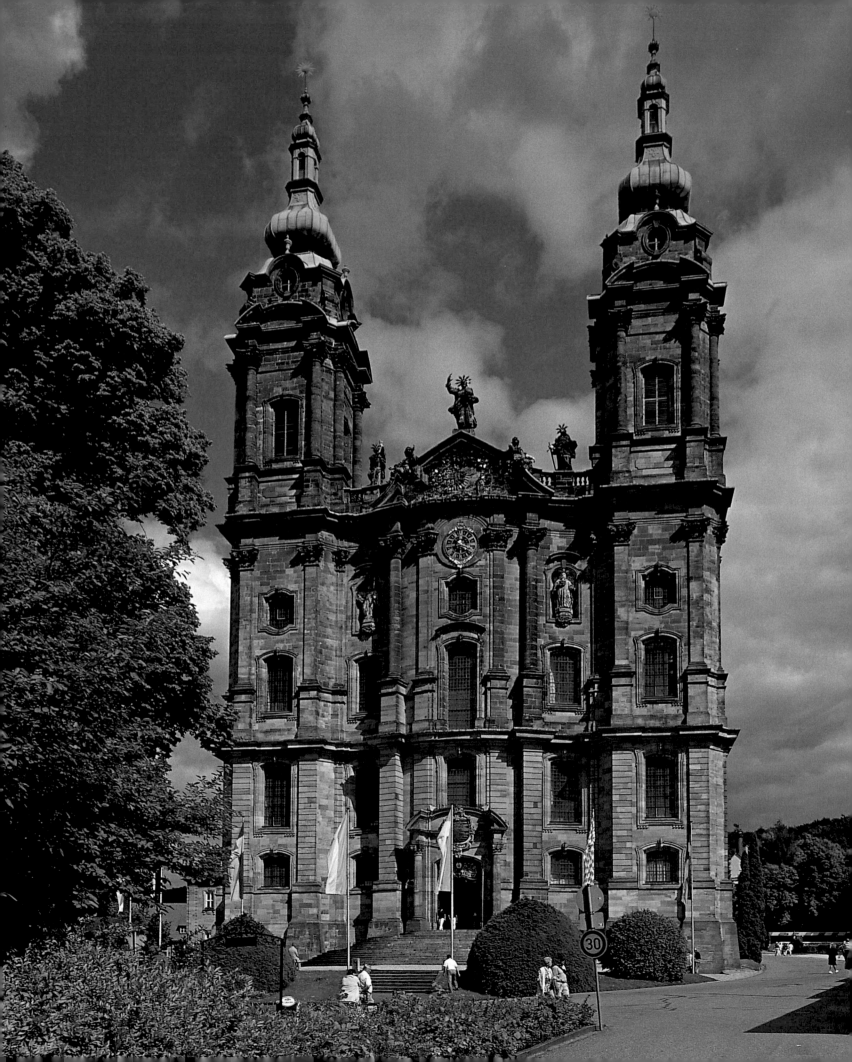

Left page:
The baroque pilgrimage church of Vierzehnheiligen near Staffelstein is the work of Balthasar Neumann, completed after his death by Johann Jacob Michael Küchel. The altar supposedly stands on the spot where in 1445 the 14 Auxiliary Saints and the Christ Child were said to appear to a shepherd from Langheim Monastery.

Seßlach in the Coburger Land may be small, but it's certainly worth a trip. Completely encircled by defensive walls and towers, entering through one of the three town gates you find yourself transported back several centuries in time. The entire village is a feat of careful restoration for which the people here were awarded first prize in a national competition held in the 1980s.

Upper Franconian Lichtenfels is the regional centre of basket weaving. This traditional handicraft is excellently documented at the German museum of wickerwork in nearby Michelau. The best place to go bargain hunting is the wicker market held once a year.

300 metres (984 feet) long and supported by no less than 16 arches, the stone bridge in the heart of Regensburg has spanned the Danube since the 12th century. Beyond it, visible for miles around, the twin spires of St Peter's Cathedral punctuate the heavens. Construction was begun on the present church after 1273.

To all intents and purposes the Oberpfälzer Wald is nothing more than the Bavarian Forest's northern little brother. At its creation, however, nature must have paused for a moment, for the chain of hills is broken at the Cham Basin and Furth Valley. This tiny orifice was large enough to allow not only traders and wagons of goods to pass through but also the armies of powerful warlords who pillaged and plundered everything in their path. For many years the Upper Palatinate was thus known as the »poorhouse of Bavaria«.

Monks were the first to settle here, compiling magnificent libraries at both Waldsassen Monastery and St Emmeram's in Regensburg, in whose scriptoria the most beautiful and valuable volumes of Carolingian manuscript were produced. The best-known is perhaps the »Codex Aureus« which the city lost to Munich in the wake of secularisation. Regensburg still has much to offer, however, with a rich history going back 2,000 years.

Although Lower Bavaria also has its fair share of spectacular scenery and picturesque towns in Passau and Landshut, it wasn't until after the Second World War that it was discovered by daytrippers and holidaymakers. Rapidly increasing numbers of guests were charmed by the rugged appeal of the Bavarian Forest; the finding of hot springs in Füssing, Birnbach and Griesbach turned them into buzzing spas practically overnight.

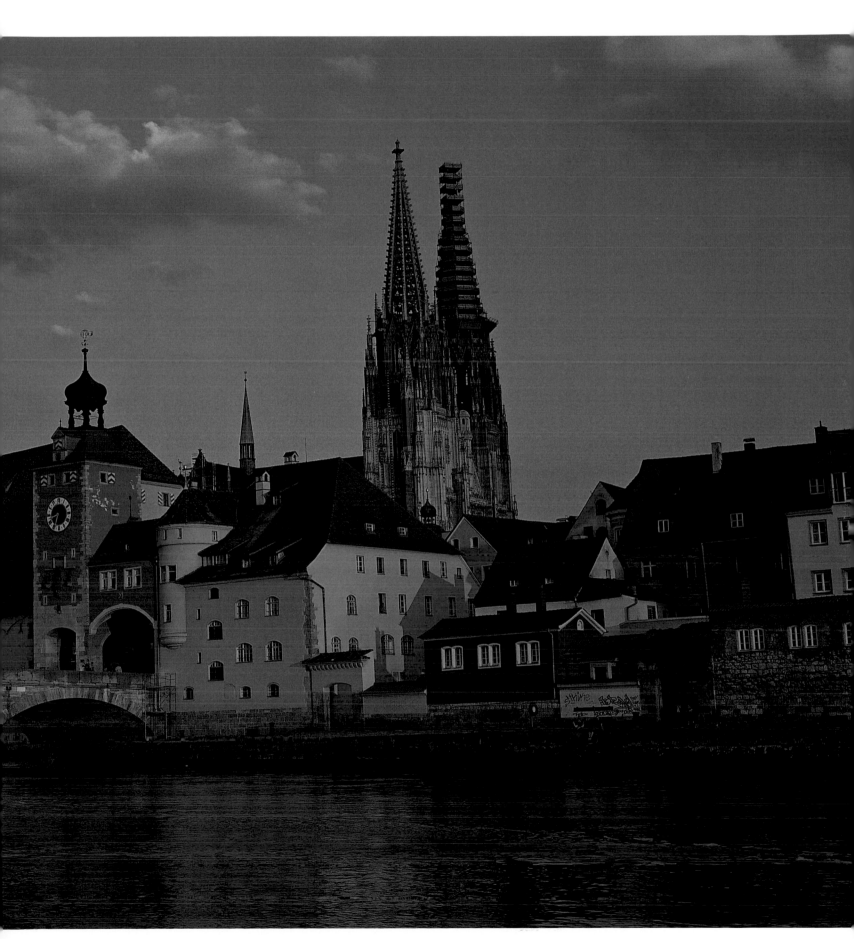

Below:

With one house glued to another and a tiny alley-way the sole passage between them, Kram-gasse in the old part of

Regensburg illustrates just how little space there was within the confines of the town walls during the Middle Ages.

Right:

View through the pillars of the Walhalla monument out across the Danube plateau. The neo-Greek temple jutting out on the horizon was built near Donaustauf by Leo von

Klenze, court architect to King Ludwig I. It houses the busts of fa-mous Germans, with a strongly male predomi-nance; just five women feature in this Teutonic hall of fame.

Above:

One of the most impres-sive dynastic towers in Regensburg is the Haus zum Goliath. With part of the foundations dat-ing back to the Roman period, the north facade

boasts a huge likeness of David and Goliath, painted in 1573 by the then most popular fresco artist in southern Germany, Melchior Bocksberger.

Right:

The Alte Linde beer gar-den in Regensburg is an atmospheric place to pay homage to King Gambri-nus, who is said to have invented the art of brew-ing and is today the patron saint of brewers.

Below:
The Kneipp health resort of Kötzting on the Weißer Regen in the Bavarian Forest has all the mod cons, including a casino. The fortified church is much older and even dwarfs the big wheel. Kötzing lies on the legendary Baierweg trail, now used solely by hikers.

Top right:
The yearly parade in Kötzting (Pfingstritt) goes back to a vow taken in the 15th century. Each Whit Monday a glorious cortege of costumed riders astride festively garlanded horses processes from the Veitskirche to Steinbühl where outdoor mass is celebrated at the Nikolauskirche.

Centre right:
Wooden boards bearing the name and details of the deceased – and often also a fitting comment or two – were once found dotted about the countryside of the Bavarian

Forest. Today these memento mori are usually exhibits in museums and only occasionally festoon the wayside, such as here in the Lamer Winkel.

Bottom right:
At the Drachenstich festival in Furth im Wald fearless Knight Udo has seven days in which to battle with a terrible fire-breathing dragon until it finally dies a spectacular death. The brave warrior is rewarded with the grateful affections of a beautiful damsel and the enthusiastic cheers of a huge audience.

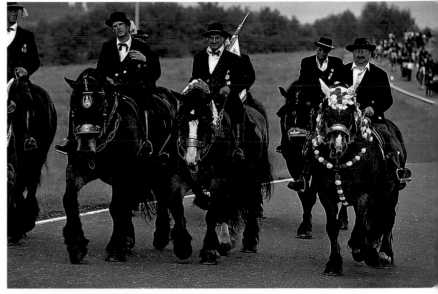

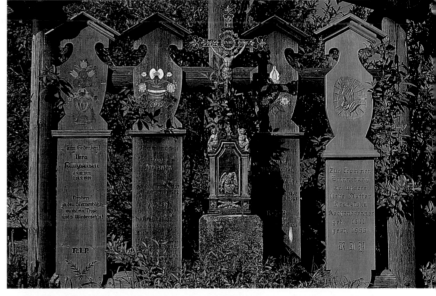

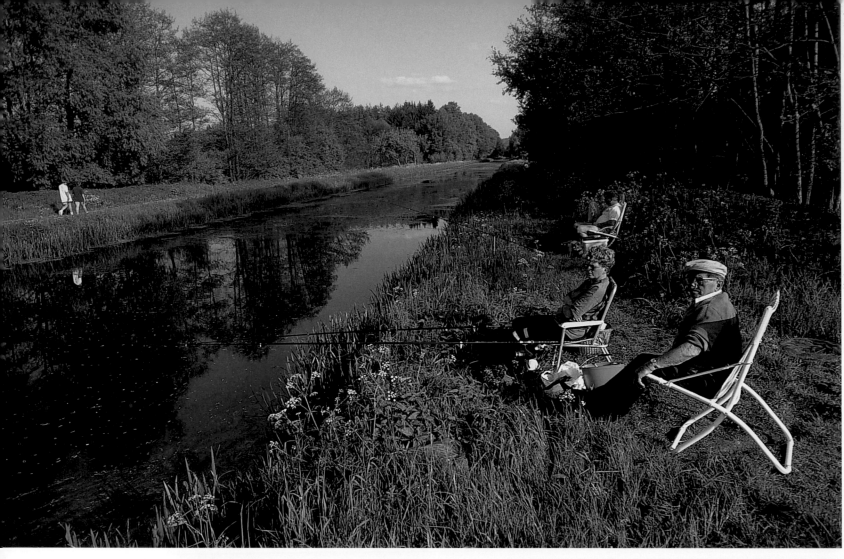

Above:

Between Bamberg and Nuremberg much of the original Main-Danube Canal built by King Ludwig I has since had to make way for its modern high-speed counterpart. Parts of the older waterway do still exist, however, such as here near Richtheim. No longer used by shipping, the still waters are an ideal spot for fishermen and nature lovers.

Right:

The forest of stone in the Upper Palatinate is named after the bizarre rock formations which shoot up from the forest floor. Covering the area between Erbendorf, Lochau, Waldershof and Mitterteich, the lonely forest is extremely popular with hikers.

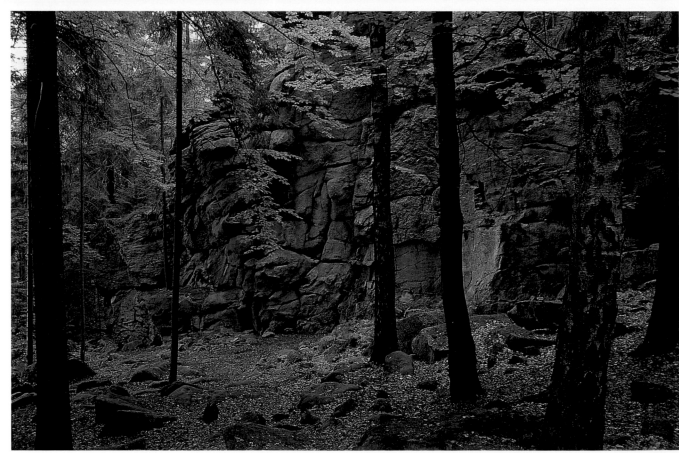

Above:
Waterwheel near Falkenberg. The village on the edge of lush forest was once ecclesiastical land and belonged to the vast estates of the former Cistercian monastery at Wald-sassen which stretched as far as Bohemia.

Left:
Burglengenfeld on the River Naab. The village atop the castle mound was named after an 11th-century fortifica-tion which suffered heavy damage during both the Landshut War of Succession and the Thirty Years' War. Only the intervention of Ludwig, then crown prince, saved it from total ruin.

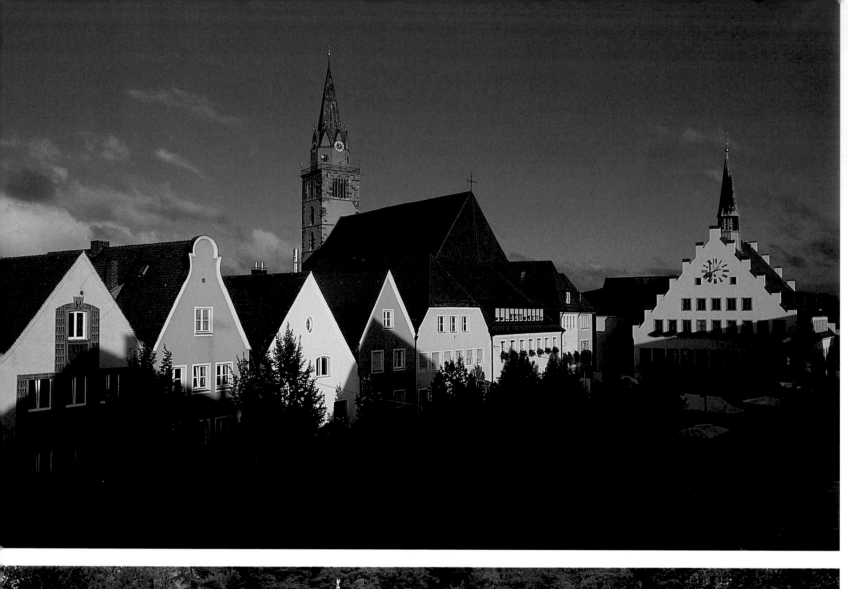

Left:

The roofs of Neumarkt with the town hall and Church of St John the Baptist. The church chancel was finished in c. 1400 with the nave needing another 50 years for completion. Together with Neumarkt's other two parish churches St John the Baptist's managed to survive the fire storm of 1944 which decimated much of the town.

Below:

The steep rocky outcrop upon which Burg Falkenberg was built in the 12th century made a curtain wall superfluous. Its steady decay was halted in the 1930s by a certain Count Friedrich von der Schulenburg, a diplomat who restored the castle to its present form but was executed for his attempted assassination of Hitler.

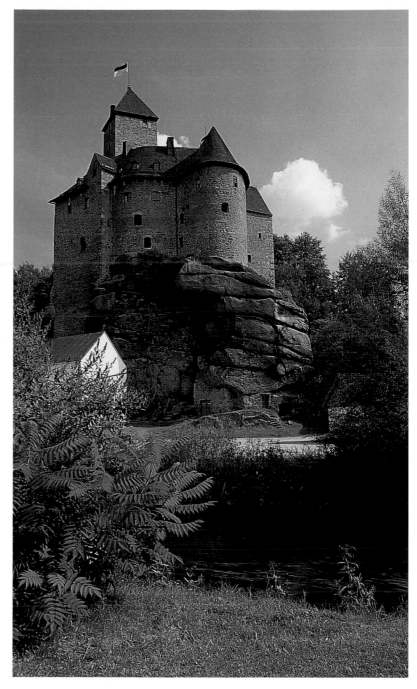

Left:

At the confluence of Vils and Naab lies Kallmünz, the »pearl of the Naab Valley«. With its castle, narrow streets and colourful array of houses and gardens, Kallmünz is the romantic's dream. Parts of the stone bridge over the Naab are 500 years old.

Above:

Weiden is the bustling centre of northeast Upper Palatinate. First documented in 1241, it blossomed during the reign of Emperor Charles IV who had his »Golden Route« run through the town on its way from Prague to Nuremberg. The town hall bang in the middle of the spacious market square was erected between 1539 and 1545 in the style of the Renaissance.

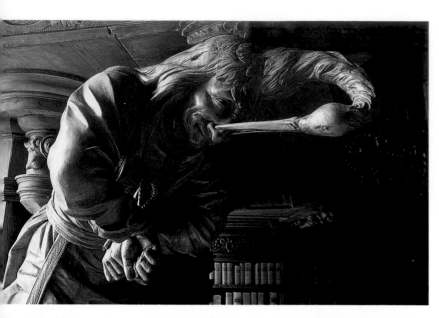

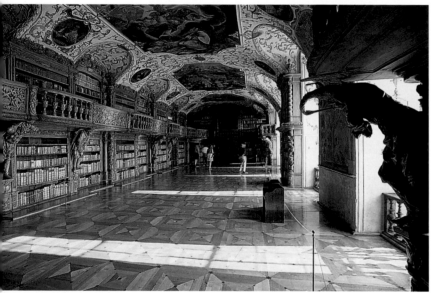

Top left:
The atlantes propping up the gallery of the library at Waldsassen Monastery are said to represent the various professions in book manufacture: the papermaker, the butcher (who provides the leather bindings), the publisher, the author, the bookseller, the reader and the critic – whose bound hands symbolise unproductiveness.

Centre left:
Karl Stilp is the name of the artist who with great wit and irony furnished the library of Wald-sassen with magnificent

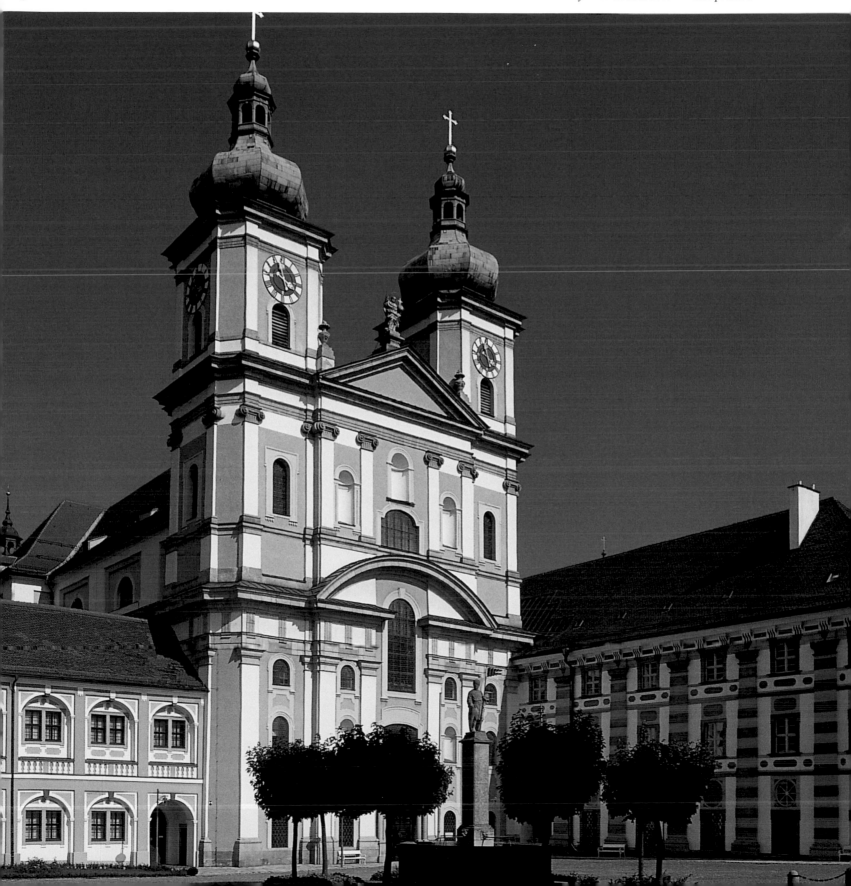

carvings. Karl Hofreiter was responsible for the ceiling frescos, with Jacopo Appiani providing the stucco.

Bottom left:
The imaginative stucco animals and figures from ancient fables and tales of fantasy seem to dance across the ceiling of Waldsassen's library, playful down to the last detail.

Below:
The architects of the present baroque basilica of Waldsassen were Abraham Leuthner from Prague and his then colleague Georg Dientzenhofer. The first little church to stand on this site was constructed in 1133 together with the monastery. At the consecration of its successor Emperor Frederick Barbarossa I was present.

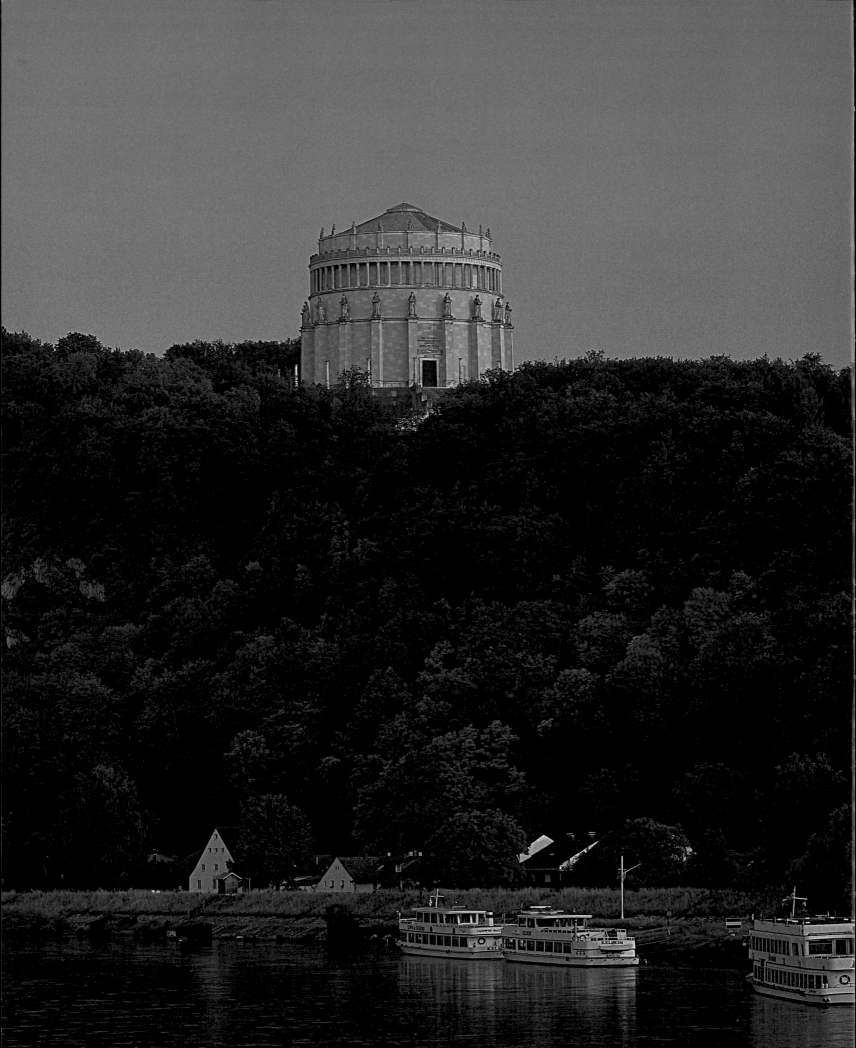

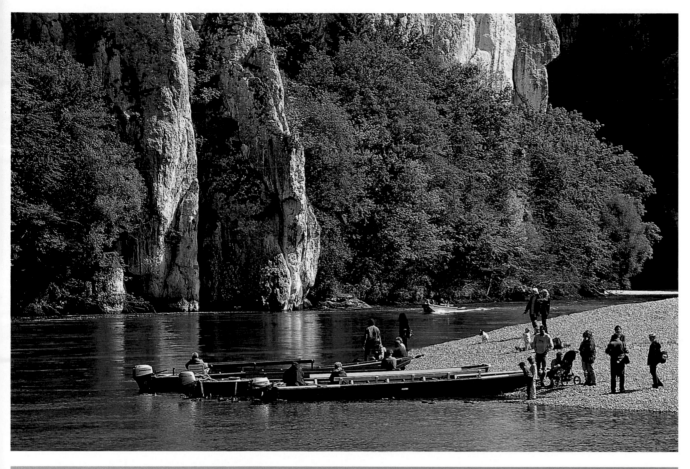

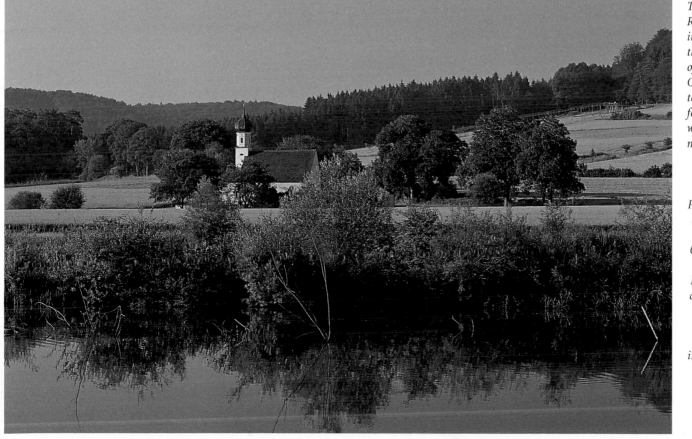

Left page:
It was King Ludwig I's idea to build a hall of liberation, the enormous Befreiungshalle, on the Michelsberg in Kehlheim, with his architects Friedrich Gärtner and later Leo von Klenze providing the plans. The temple was opened to the public in 1863, 50 years after the bloody Battle of the Nations at Leipzig.

Just outside Kehlheim the Danube has carved its way through a mighty stone obstacle. In a process taking millions of years the river has bored a channel through the mountain to create a magnificent gorge. It was here that in 760 a small monastic cell was made the abbey of Weltenburg, still a functioning monastery.

The valley of the Altmühl River has lost much of its unadulterated charm through the construction of the new Main-Danube Canal. Today you have to search long and hard for unspoilt stretches of water, such as this one near Riedenburg.

Page 116/117:
View of the old town of Passau from the pilgrimage church of Mariahilf. Passau originated as a Celtic fort which became the Roman camp of Bojodoro. In c. 200 AD a castle was erected on the hill in the old town, manned by a Batavi cohort. Their name was in turn used to designate the military camp: Castra Batava. Over the course of the centuries Castra Batava was changed to Passau.

115

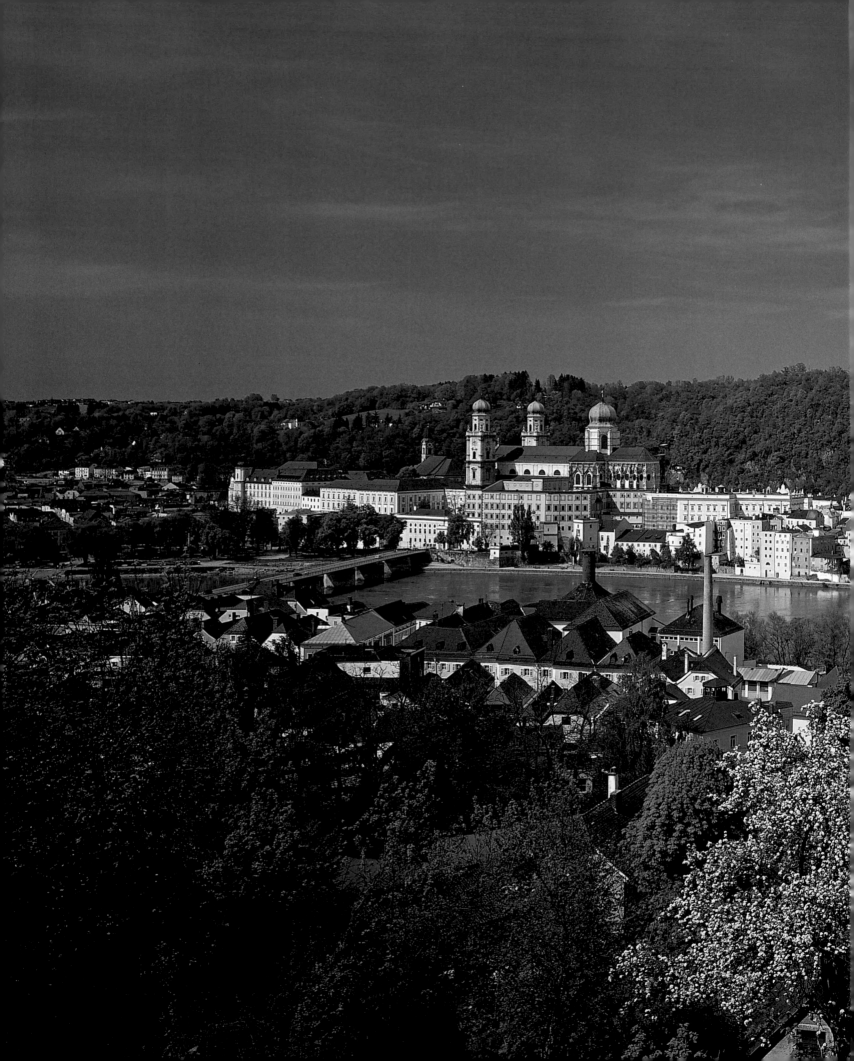

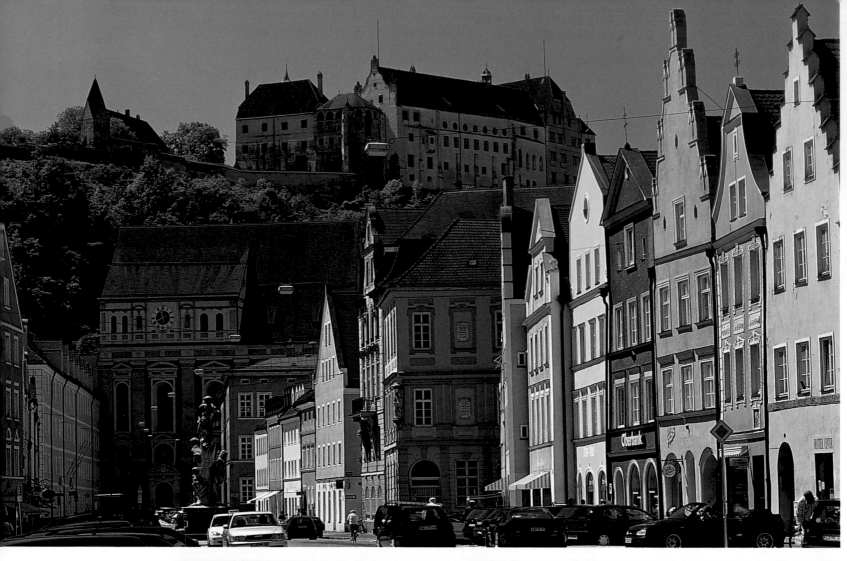

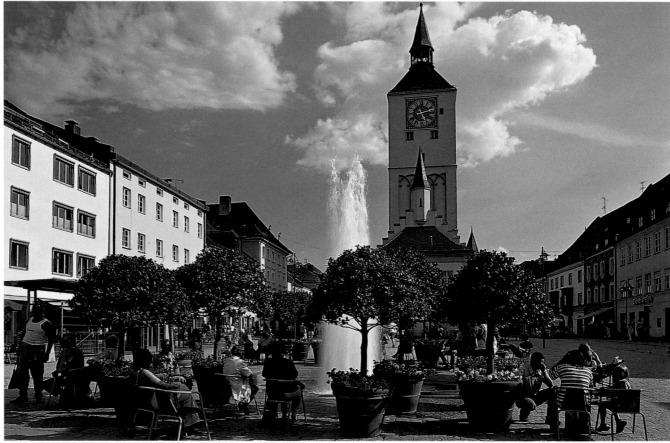

Above:
Landshut, the castle on the hill and the settlement on the river, royal seats in the 13th, 14th and 16th centuries, date back to the year 1204. The photo looks up from the »new town« to Burg Trausnitz, whose double chapel of St George's is from the 13th century.

Right:
Deggendorf, near where the Isar flows into the Danube, was recorded as a small settlement in 868. The heart of the town, its layout typically Wittelsbach, is the wide market street with its gabled town hall from 1535 and the watchtower rising proud behind it, its present size a bequest of the 18th century.

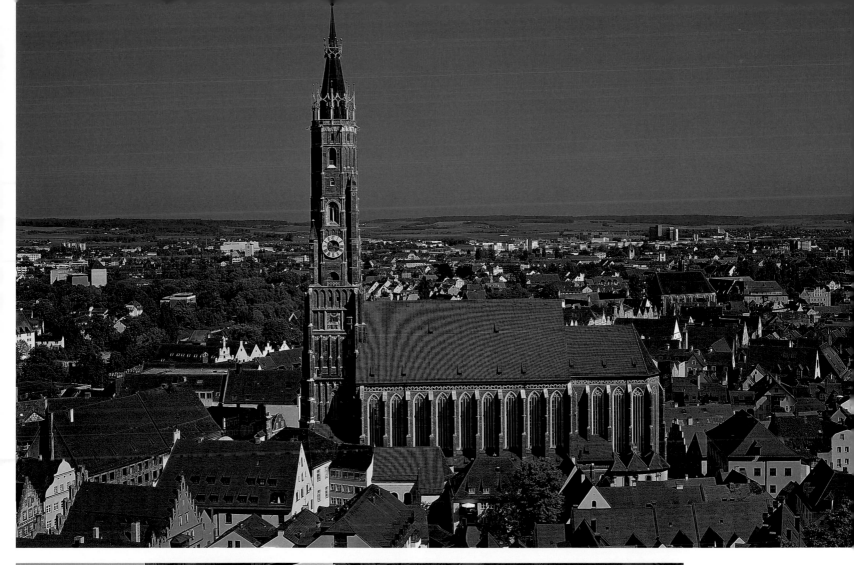

Above:
From Trausnitz castle high up above Landshut the sea of houses is dominated by the late Gothic church of St Martin's. The enormous steeple, completed in c. 1500, is the highest in Bavaria.

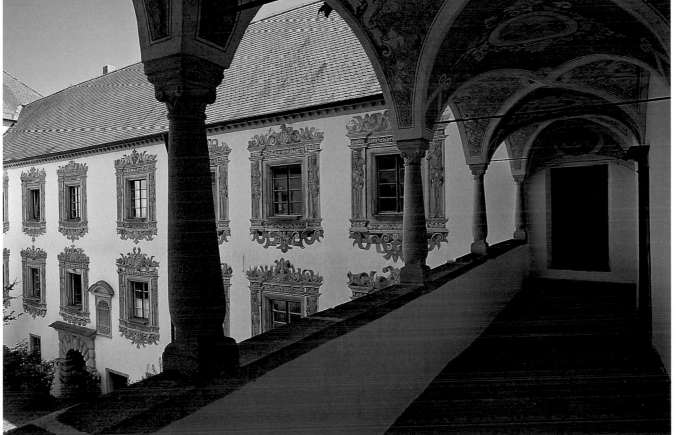

Left:
Schloss Ortenburg in the Wolfach Valley is the ancestral seat of the counts of Kraiburg-Ortenburg, once one of the most powerful aristocratic families in Bavaria. The Renaissance palace with its wonderful inner courtyard now houses a museum of local history.

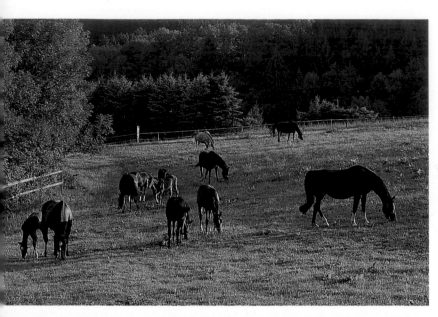

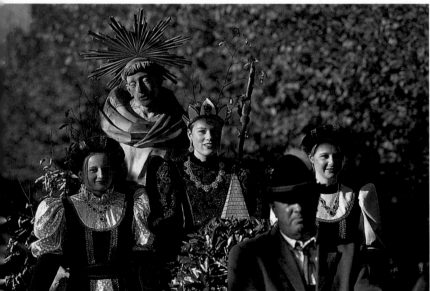

Top left:
The fertile expanses
of the Rottal have been
farmed for centuries.
Its farmhouses, known
locally as Stockhäuser,

have a unique architec-
tural style and seem to
effuse the simplicity and
serenity of the country-
side seldom found in our
modern world.

Centre left:
St Leonard's Day proces-
sion in Aigen. The pil-
grimage chapel dedicated
to the patron saint of
horses has been a shrine
to a picture of the Virgin

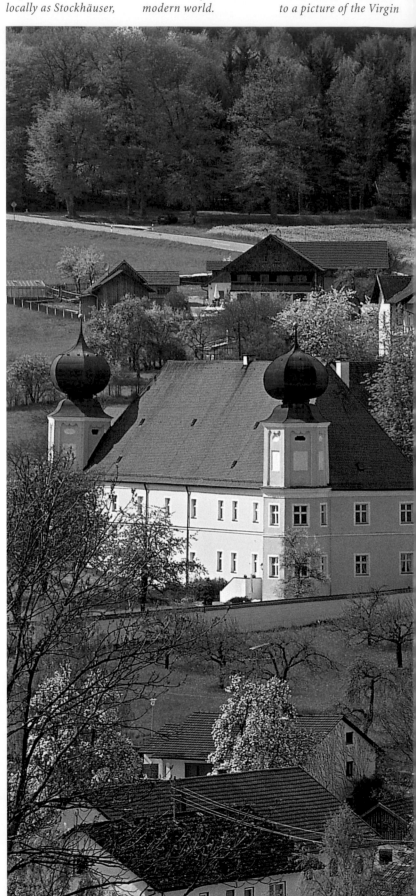

Mary for ca. 800 years. Claimed to have miraculous powers, the likeness is said to have been washed to its present location by the River Inn.

Bottom left:
The idyll of the countryside at Bad Griesbach. The discovery of hot springs and the subsequent erection of chic spa rooms in 1977 heralded the dawn of a new era for Griesbach. Since then the village has seen a steady influx of guests coming to take in the healing waters and the marvellous scenery.

Below:
The Church of St Salvator's near Bad Griesbach was once part of a Premonstratensian monastery. Inside are altarpieces by the famous sculptor Josef Deutschmann which originally stood in St Nicola's near Passau and were auctioned off during the wake of secularisation.

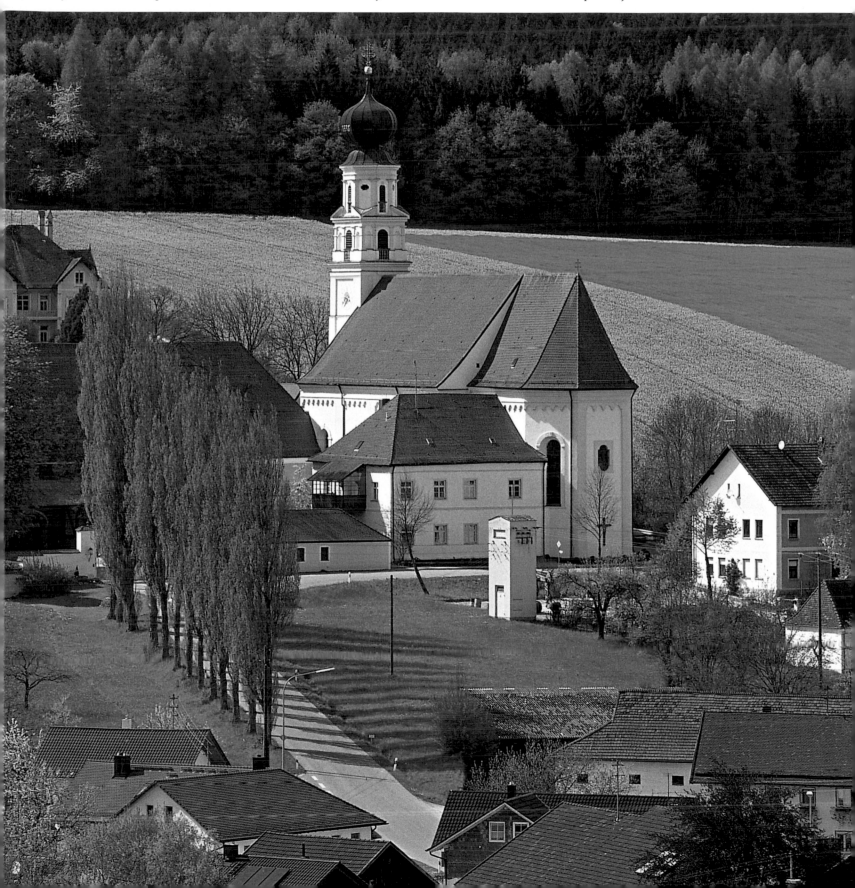

INDEX

Index.................Text.................Photo Index.................Text.................Photo Index.................Text.................Photo

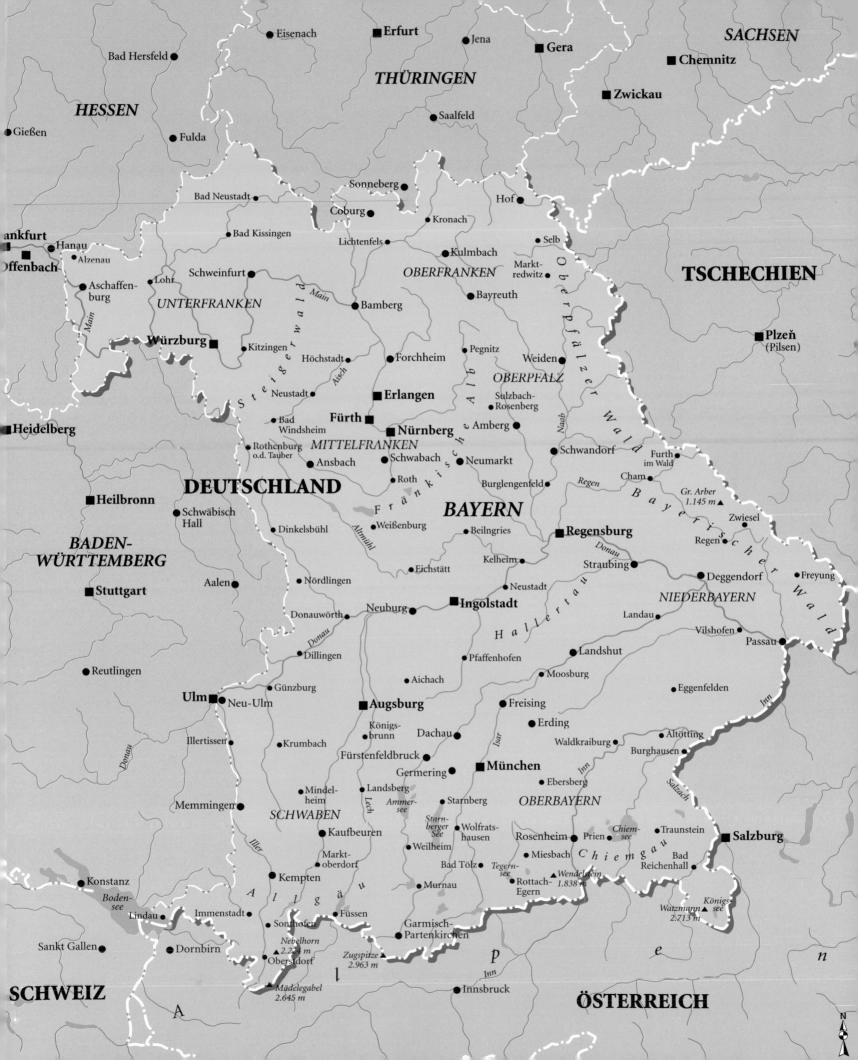

Traditional costume in Königsdorf near Bad Tölz. Beneath the village lies the largest stretch of high moorland in Upper Bavaria.

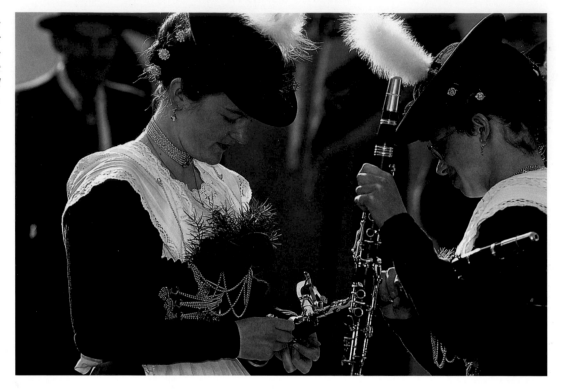

Credits

Design
hoyerdesign grafik gmbh, Freiburg

Map
Fischer Kartografie, Fürstenfeldbruck

Translation
Ruth Chitty, Schweppenhausen

All rights reserved

Printed in Germany
Repro by Artilitho, Trento, Italy
Printed/Bound by
Offizin Andersen Nexö, Leipzig
© 2003 Verlagshaus Würzburg GmbH & Co. KG
© Photos: Martin Siepmann

ISBN 3-8003-1610-2

Stürtz